SUNDERLAND
THROUGH TIME
Keith Cockerill

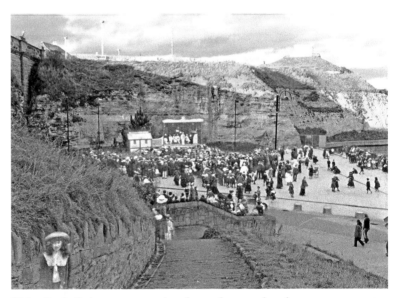

Holey Rock, Roker – a composite of two photographs taken a century apart

AMBERLEY

Acknowledgements

Derek Blakelock, James Bryce, Tom Hutchinson, Marjorie Murray, George Nairn, Pat O'Brien, Sybil Reeder, Alf Rodenby, Douglas Scrafton, Stephen Smith, Brian Wharmby, David Wood, South Hylton Local History Society, *The Sunderland Echo*, Sunderland Museum and Winter Gardens, Tyne and Wear Museums, Newcastle University – Robinson Library Special Collections – local illustrations.

Special thanks to my wife Joan for her help and encouragement during the creation of this book.

First published 2009
Reprinted 2011

Amberley Publishing
Cirencester Road, Chalford,
Stroud, Gloucestershire, GL6 8PE

www.amberley-books.com

British Library Cataloguing in Publication Data.
A catalogue record for this book is available from the British Library.

ISBN 978 1 84868 576 5

Typesetting and Origination by Amberley Publishing.
Printed in Great Britain.

Introduction

The face of Sunderland is changing at a greater rate than ever before. Those of us who live within its boundaries don't always consciously observe this change. It often takes a visit from a family member or friend who has moved away, to remind us of the many alterations to our city. Nowadays, as old utilitarian buildings are demolished and new constructions planned, much grander – sometimes 'iconic' architectural designs are proposed as replacements. It is likely therefore, that our skyline will be transformed over the next fifty years or so.

But what did Sunderland and its surrounds look like more than a century ago? If we step back beyond living memory, we must rely on paintings, sketches and old photographs to see how we once looked. When studying old views of the area, it is often quite difficult to place these scenes into their modern context. This book strives to achieve that aim, with an accurately composed collection of 'past and present' views of the city. I have also gone 'out and about' to reflect the six boundary extensions to the borough that have occurred in the last 114 years and have visited one of our nearest village neighbours. The reader may be familiar with some of the paintings, drawings and photographs featured, but several Victorian sketches published within this book have not been in print for around 150 years.

Throughout the nineteenth and early twentieth centuries, artists and early photographers provided us with many fascinating images of the borough, but recreating them in the panorama and perspective in which they were originally conceived can prove difficult. I have attempted to replicate the perspective created by the eye of the artist or the early camera lens by the manipulation of a set of digital images taken of those same scenes today. Often, two or more photographs have been 'stitched' together to recreate the panorama of the original view. The end result is a set of pictures that closely resemble those original old scenes and which offer an opportunity for the reader to study how time has changed them. Where time has greatly changed the view today, I will describe a point within the scene – a 'key feature', which has enabled me to frame the modern view with some accuracy.

If the nineteenth-century artist or photographer could return to modern Sunderland today and recreate their images of yesteryear, then perhaps this is how they would look!

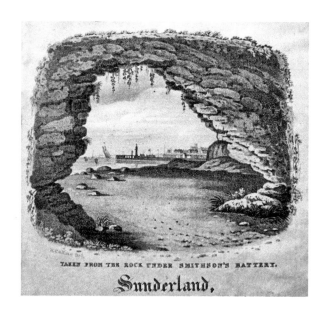

TAKEN FROM THE ROCK UNDER SMITHSON'S BATTERY.

Sunderland,

Garbutt's Sunderland

This 1819 view is taken from George Garbutt's *History of Sunderland* – the first printed history of the town, which was published in that year. The artist was H. Collins. The image appears as the frontispiece to the old book and shows a view looking south towards the piers and harbour from 'inside' Holey Rock at Roker.

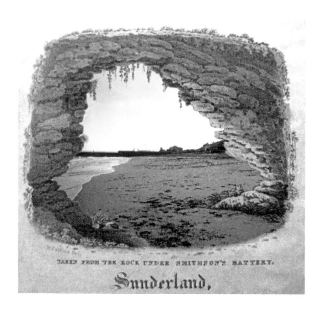

TAKEN FROM THE ROCK UNDER SMITHSON'S BATTERY.

Sunderland,

If Holey Rock had not been demolished in the mid 1930s, this is how the same scene would look today! The north pier of 1903 now sits in front of its predecessor of 1795.

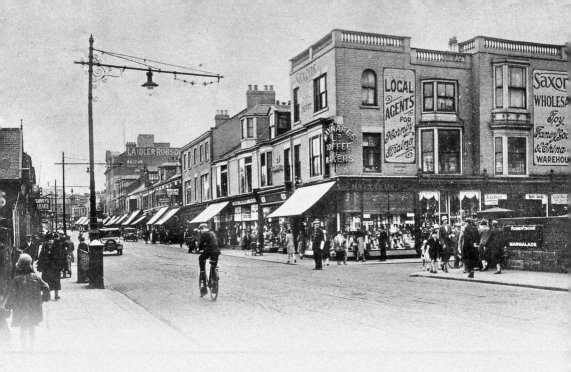

chapter 1

The Town

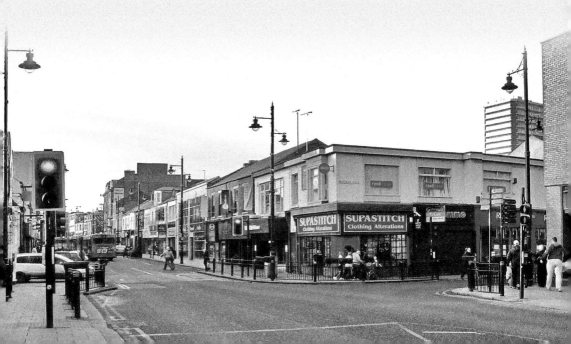

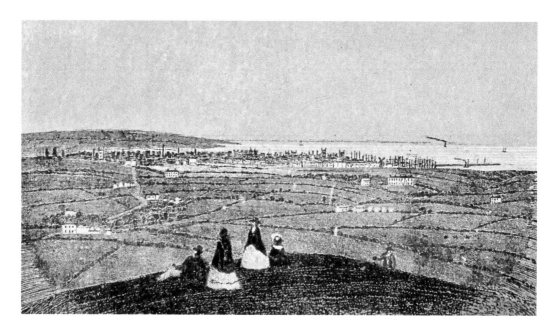

Sunderland from Tunstall Hill

This very interesting panoramic image of Sunderland, as viewed from the top of Tunstall Hill was created by Rock & Co. of London around 1858. The church towers of Bishopwearmouth, Holy Trinity and St. John's can all be seen on the skyline. Sailing ships are at berth in the South Dock of 1850, whilst a steamer enters Hendon Bay.

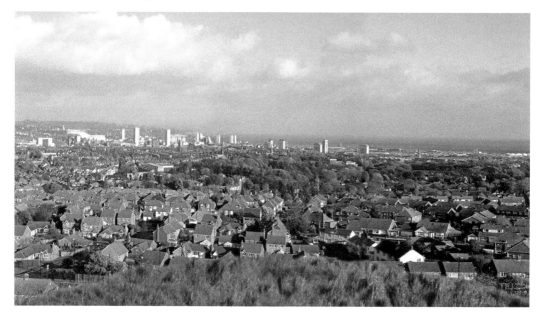

On this modern view, multi-storey flats now dominate the city skyline and Sunderland's boundaries have reached beyond Tunstall Hill itself! The Stadium of Light (left centre) is clearly visible. Holy Trinity church can no longer be seen from this vantage point as it sits beyond the towers of South Durham Court and Hedworth Court.

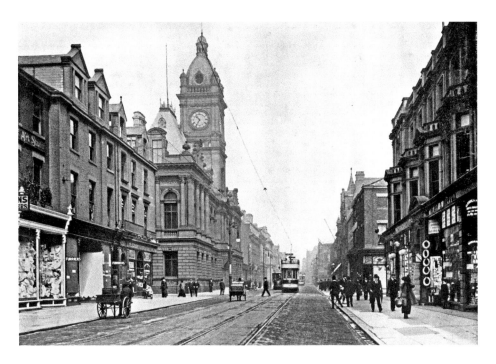

Fawcett Street looking North

How elegant Fawcett Street looks complete with its imposing Victorian town hall. The foundation stone was laid on 29th September 1887 and was opened November 1890 at a cost of £48,000. The Athenaeum building can be seen to the right.

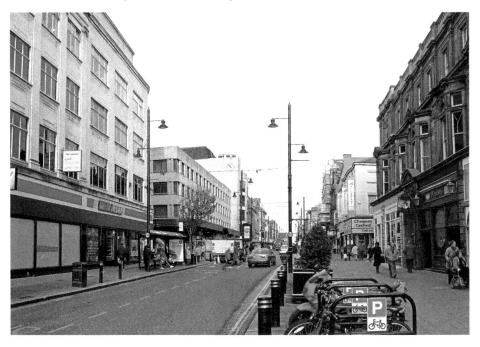

Things never looked quite the same for Fawcett Street after the town hall was demolished in 1971. The modern narrow thoroughfare also seems to detract from its general appearance.

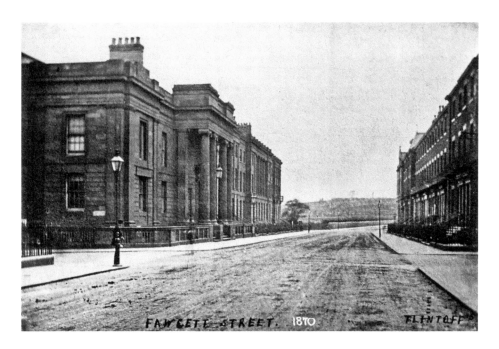

Fawcett Street looking South

This early Flintoff photograph of 1870 shows the Athenaeum building in all its grandeur. It was designed by William Billington and built between 1839 and 1841 to house the Literary and Philosophical Society. The museum on Borough Road beyond was yet to be erected. On Building Hill, there is just a faint outline of the statue of General Havelock.

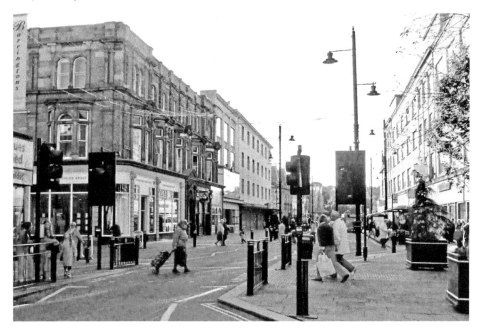

The Athenaeum lost its portico around 1900 when an extra storey and bay windows were also added. The museum of 1879 can just be seen on Borough Road.

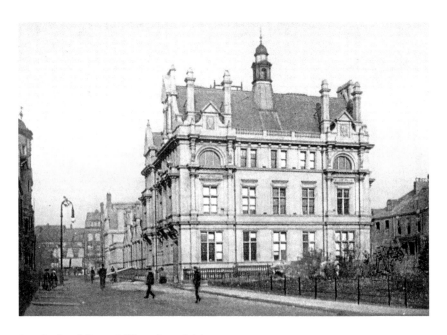

Sunderland Post Office, Sunniside

A postcard showing the central post office in West Sunniside around 1906. It was built in the Jacobean style by Sir Henry Tanner and opened in 1903. To the right of the building is a glimpse of Norfolk Street, which was home to several of Sunderland's nineteenth-century ship owners.

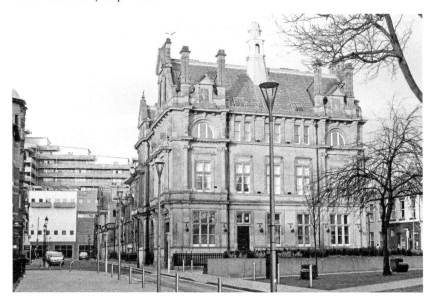

The Grade-II* listed building stood vacant for fifteen years, before a £7 million award-winning development began in 2002 to convert it into thirty-two apartments. The historic area of Sunniside in Sunderland's 'eastern quarter' has seen considerable investment in the last six years and has the highest concentration of listed buildings in the city. To the left of the post office, the new River Quarter development is currently under construction – a modern mix of leisure and living space.

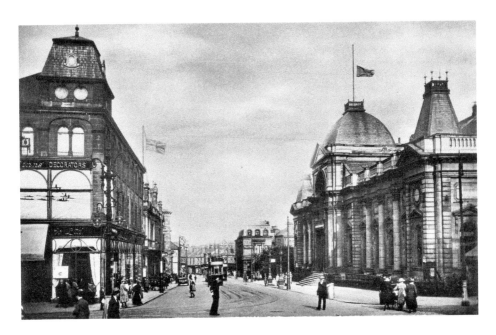

Borough Road

This picture postcard of around 1910 shows two flags flying at half-mast, possibly in mourning for King Edward VII? The museum and art gallery opened on 6 November 1879. The Palatine Hotel can be seen just beyond the museum. Binns store (Fawcett Street east side building) was severely damaged in April 1941 by an incendiary bomb.

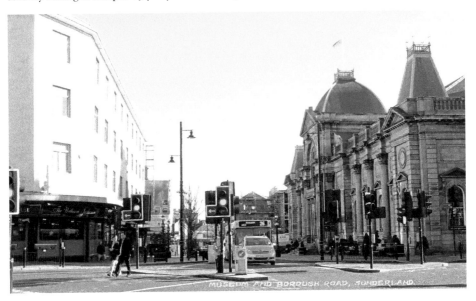

From this viewpoint, the museum looks much as it did when it was first erected. In 2006 the new Mowbray apartment complex is under construction. Binns store (left) on the east side of Fawcett Street, having been rebuilt by 1962 closed its doors for good in April 1989. The William Jameson P.H. now occupies the ground floor of this building, with the city library and art centre above. Note that Binns other store on the west side of Fawcett Street (off picture) was gutted by the same bomb, but reopened in March of 1953 where it continued to operate until January 1993.

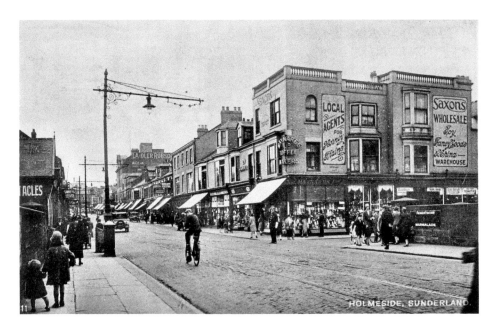

Holmeside

Many of the old shop names of Holmeside can be seen in this postcard view from the late 1920s. Amongst them are Turvey's Garage, furniture dealer Laidler Robson and Maynard's sweet shop. At the junction of Holmeside and Waterloo Place is Saxon's toyshop, which advertises itself as a 'local agent for Hornby trains', a 'Meccano depot' and a 'wholesale toy, fancy goods and china warehouse'.

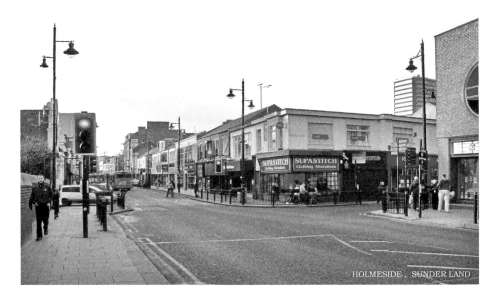

In 2009, Holmeside is still a busy thoroughfare for both buses and city shoppers. Joseph's moved from Union Street into Saxon's former premises in 1959, before closure in 1991, although they continued to operate for another six years in premises further along Holmeside. The corner store has lost its upper storey and is now occupied by Supastitch, above which is a staff agency.

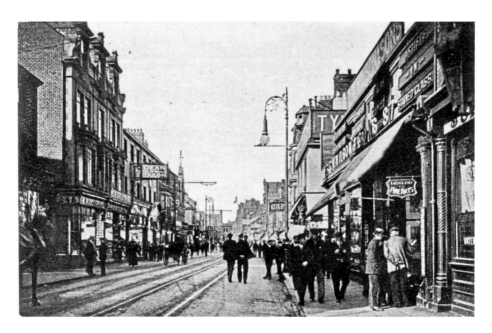

High Street West

An animated view of High Street West taken around 1912. The corner of Blackett's Store just sneaks onto the picture on the very far left. Adjacent to the premises of F. Reed is Dean 'the-up-to-date tailor'. Far right is C.W. Wilson & Sons and further along the street, Strother's premises are just visible.

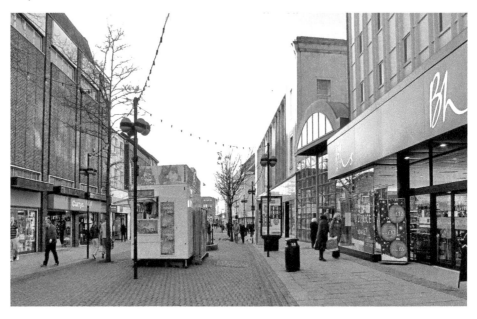

Very little remains of the old High Street West on this 2008 photograph. The 'key feature' used to frame this modern view was the building formerly occupied by Dean the tailor (centre left). On the right today are British Home Stores and Marks and Spencer, between which is sandwiched the covered walkway across St. Mary's Way to the car park.

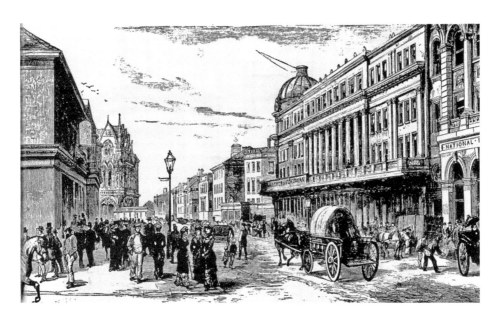

High Street West

A Flintoff print of a bustling High Street West around 1880. Hutchinson's Buildings (right) were erected in 1850 on the site of Dr. Clanny's old house. Silk hat maker Mr Mackie ran a shop in a part of these buildings. Havelock House (left) was on the opposite corner. Frank Caw's gothic Elephant Tea House (beyond Havelock House) was built between 1873 and 1877 for tea and coffee merchant William Grimshaw. Far right is the National Provincial Bank of 1876. The 'great fire' of 18 July 1898 destroyed Havelock House. It was rebuilt within eighteen months and in 1914 became a cinema. Hutchinson's Buildings were also badly damaged by the fire.

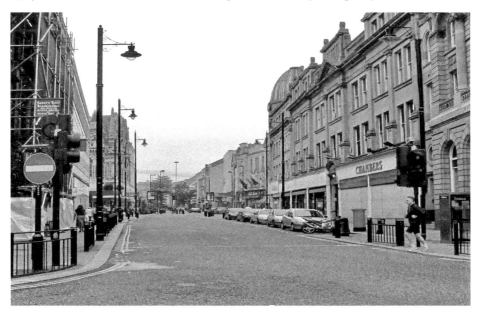

Hutchinson's Buildings, The National Provincial Bank building and The Elephant Tea House structure all survive externally intact, to make these two 'past and present' images look very comparable.

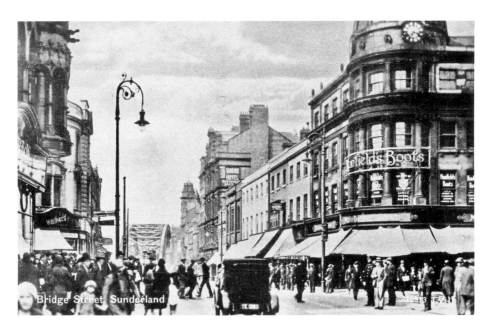

Bridge Street

A mid-1930s postcard view of Bridge Street looking north towards Wearmouth Bridge. The card is franked for 27 February 1936. The Grand Hotel (centre) was 'Sunderland's leading family and commercial hotel'. Far right on Mackie's Corner is Manfield & Sons. The Elephant Tea House can again be seen to the left of the picture.

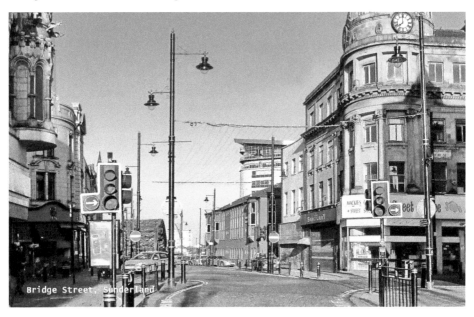

On a Sunday morning in December 2008, things look much more peaceful. The Grand Hotel was demolished in the late 1960s along with adjacent properties for ring road improvements. Behind the replacement properties is the Echo 24 development of 2006. A sweet shop now trades on Mackie's Corner.

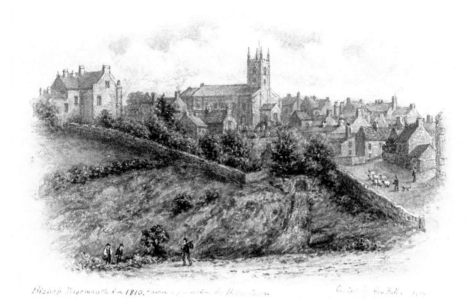

Bishop Wearmouth c 1810. — ... — *Geo. Fall, 1904*

Bishopwearmouth

A 1904 watercolour by George Fall, copied from an 1810 painting by H. Davison. St. Michael's church (centre) was rebuilt between 1806 and 1810, but churches may have existed on this site since the tenth century. The old rectory can be seen to the left. The village has a quaint rural look to it and the burn runs down to the river above ground at this time. (Watercolour courtesy of Sunderland Museum and Winter Gardens, Tyne and Wear Museums).

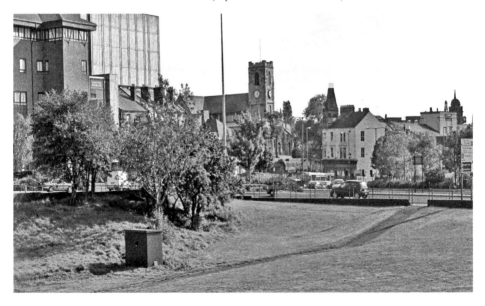

Additional alterations to the church took place in 1850, 1872, 1874, and 1887 and it was further restored in 1932. Following the granting of 'city status', the church was renamed Sunderland Minster on 11 January 1998. Modern Bishopwearmouth itself looks very different today! The burn now runs underground via a culvert. Far left is Wear View House, home to the Department of Work and Pensions and the controversial fly-tower extension to the Empire Theatre can be seen adjacent.

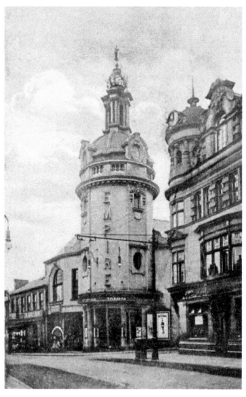

The Empire Theatre

The theatre was designed by W. & T.R. Milburn and financed by Richard Thornton, a former busker from South Shields. Vesta Tilley laid the foundation stone on 29 September 1906 and took to the stage on 1 July 1907 to declare the venue open. It was first known as the Empire Palace. The domed tower was surmounted by a revolving sphere on which stood Terpsichore the Greek goddess of dance. During World War Two, the globe and statue were removed for safety after a bomb fell close to the theatre. The Dun Cow (right) was designed in baroque style by B.F. Simpson for R. Deuchar Ltd and was erected in 1901.

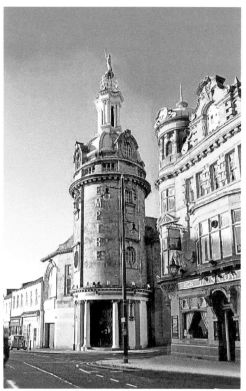

The scene looks almost identical today from this viewpoint. Off picture, however, is the contentious theatre fly-tower, which was erected in 2004 at the same time as other refurbishments to the theatre. The original statue of Terpsichore must now be viewed at the head of the main staircase inside the theatre and a replica is now in place on the dome itself. The splendid original Indo-Gothic back-bar of the Dun Cow has survived the modern trend of creating 'themed' drinking venues.

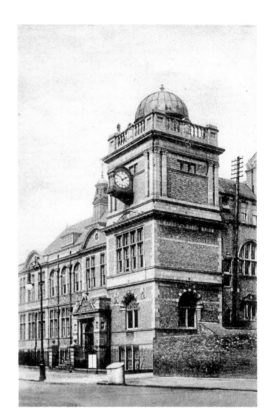

Sunderland Technical College

A view of Sunderland Technical College, which opened in 1901. The Galen Building was erected in Green Terrace at a cost of £27,800. It was the first college in England to introduce 'sandwich courses', which enabled its engineering students to gain their qualifications whilst in employment.

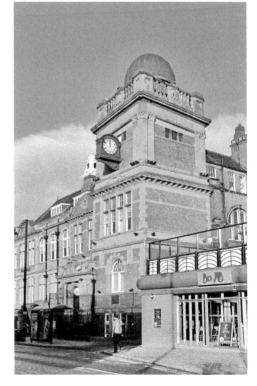

The college was further extended between 1922 and 1930 and the Priestman Library was opened in 1939. In the late 1950s it was the first college in the region to install a modern computer. Sunderland College became a polytechnic on 1 January 1969. In 1992, the polytechnic gained university status. Today, a nightclub operates within the Galen Building and its new neighbour (right) contributes to Sunderland's modern bar scene.

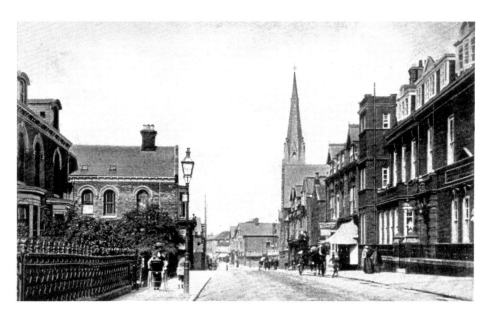

Stockton Road

A fine view of Stockton Road, taken around 1905. The spire of West Park United Reformed Church (1881-83) is prominent in the picture (centre right). Far right is Sunderland and County Durham Eye Infirmary, which moved here from Crowtree Terrace in 1893. Beyond Grange Terrace (extreme left) are the end properties of Argyle Street.

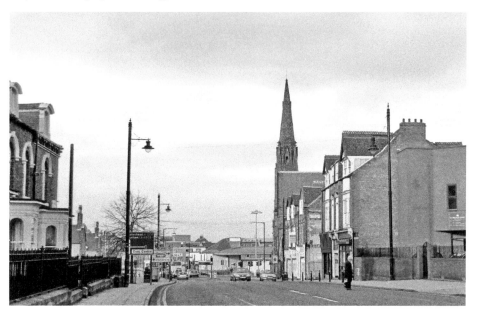

The Eye Infirmary relocated to new premises in Queen Alexandra Road in 1940. Demolition of the old infirmary began in 1978 and The Sunderland Free Church was erected on the site. The old adjacent building now houses 'The Bunker' recording studio. A dental surgery and The Spiritualist National Church now reside in the two properties of Grange Terrace that can be seen to the left. The end properties of Argyle Street were demolished in the mid 1980s. The city's central bus station can be seen to the lower centre of the picture.

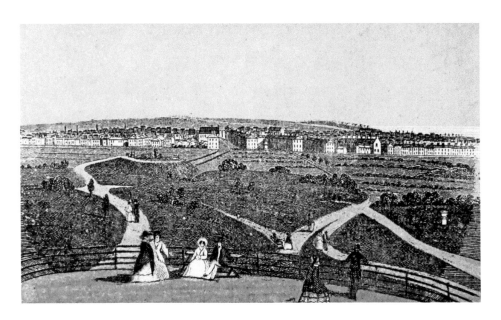

Sunderland from Building Hill

Another fascinating panoramic Rock & Co. print of Sunderland that was drawn around 1862 from the vantage point of Building Hill. Only the Mowbray Park of 1857 is in view – the extension of 1866 to Borough Road was yet to come. The sketch also pre-dates the museum and art gallery. The line of Fawcett Street can be clearly seen.

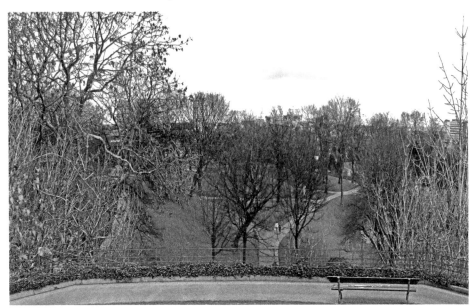

The maturing of Mowbray Park means that little of the city centre's modern skyline can now be seen from Building Hill, even though the photograph was taken after leaf fall. The 'key feature' used to frame this shot, is the 'Y' shaped pathway (lower centre).

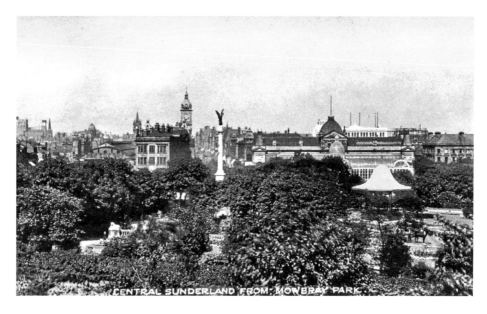

Central Sunderland from Mowbray Park

A lovely hand-coloured postcard that dates to around 1930. It was taken from the vantage point of the Jack Crawford memorial within the park. The Museum and Winter Gardens are prominent to the right of Fawcett Street. In line with Sunderland's main thoroughfare is the War Memorial of 1922. The town hall is visible to its left. Left again, the north and south entrances of the Central Railway Station of 1879 can be seen.

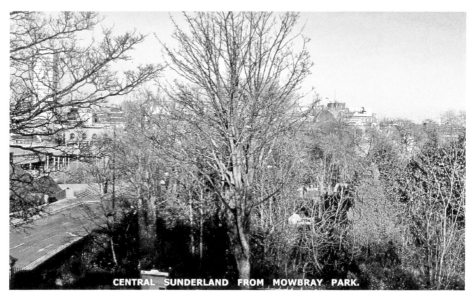

Tree growth now hides much of the city centre from the same vantage point, but the central dome of the museum is still visible. The old Winter Garden terrace was badly damaged during an air raid in April 1941. The new Winter Gardens, now slightly to the east of the museum, were officially opened on 19 July 2001. Their glass dome is just visible far right. The splendid old north entrance to the railway station (architect William Bell) was demolished in 1966.

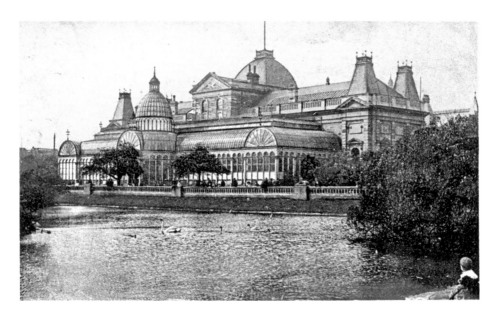

The Winter Gardens and Museum

A wonderful Edwardian view of the Victorian Winter Gardens and Museum across Mowbray Park lake. They were a great source of pride to the people of the town. The author's mother recalls dressing up in her 'Sunday best' to visit them as a child before the war. The Winter Gardens are said to have been based on a model of The Crystal Palace in London.

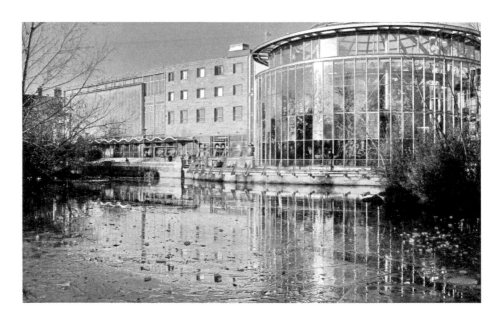

The same scene on an icy December day in 2008. The library extension of 1960/64 (left) and new Winter Gardens (right) now obscure the original museum structure from this viewpoint. The 'key feature' used to frame the shot was the Union Jack on the flagpole of the museum's central dome.

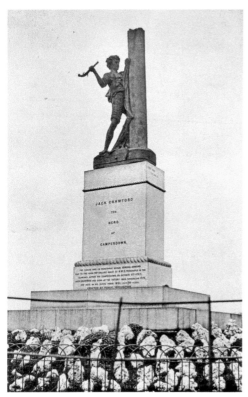

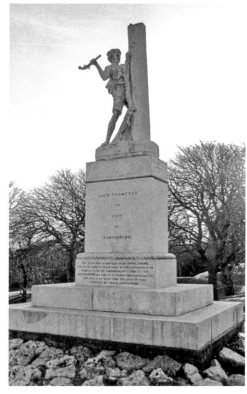

Jack Crawford Memorial, Mowbray Park

Above left: An early twentieth-century view of the Jack Crawford memorial that was unveiled in Mowbray Park in 1890 by Lord Camperdown. The Sunderland hero served on H.M.S. *Venerable*, the flagship of Lord Duncan at the battle of Camperdown. On 11 October 1797, the flagship had her mast top and flag shot away in the heat of the battle and young Jack promptly climbed the mast to nail the Admiral's colours back in place. The British Fleet were victorious and Jack became a national hero.

Above right: Jack's monument still stands proudly today in Mowbray Park. At the foot of nearby Building Hill, a small stone seat (see next page) allows a slightly different view of the monument and provides sound advice for us all!

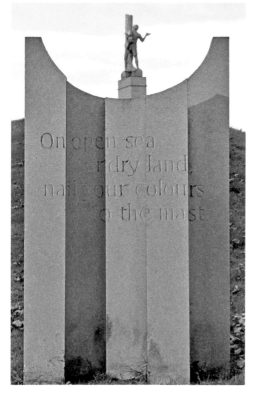

Left: 'On open sea or dry land, nail your colours to the mast'.

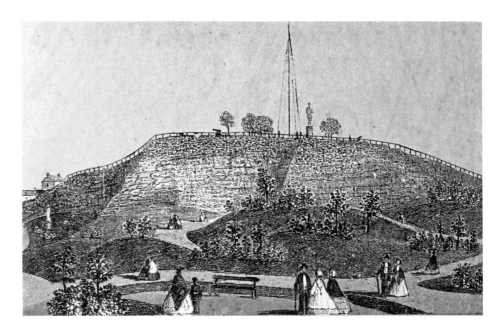

Building Hill, Mowbray Park

An accurately dated Rock & Co. print of Building Hill in Mowbray Park sketched on New Year's Day 1862. The Corporation purchased the mount, also known as Boyldon Hill, in 1854 and the first phase of Mowbray Park opened in 1857. General Sir Henry Havelock K.C.B. died 24 November 1857 and his statue (centre right) was raised 5 April 1861. There is a glimpse of the cannons captured from the Russians at Sebastopol in 1855.

Mowbray Park suffered bomb damage during World War Two and the Russian guns were removed and melted down to make contemporary weaponry. The cannons seen today on Building Hill are therefore replicas. The viewing seat for the Jack Crawford memorial (see previous page) can be seen bottom right.

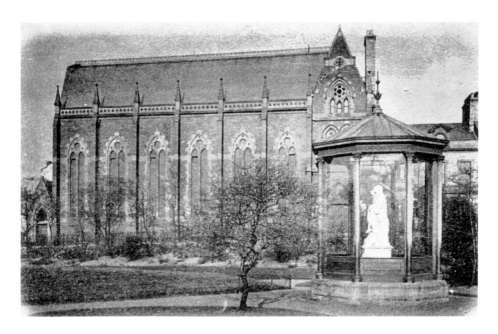

The Victoria Hall and Memorial

This early postcard shows the Victoria Hall before its extension of 1906. It was erected in 1872 at a cost of almost £13,000. On 16 June 1883, a terrible disaster unfolded at the hall and 183 children lost their lives. As children stampeded downstairs from the galleries to make their way into the stalls where presents were being distributed, a partially open, but bolted door caused those at the front of the scramble to be trapped and tragically crushed to death. The memorial (right) commemorates this frightful calamity. Three of the author's ancestors were lost on that dreadful day.

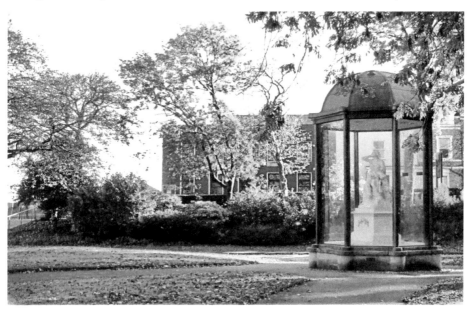

The memorial was later relocated to Bishopwearmouth cemetery, where over the years it gradually fell into disrepair. On 12 April 2002, however, the statue having been restored and given a new canopy was brought back to its rightful place in Mowbray Park.

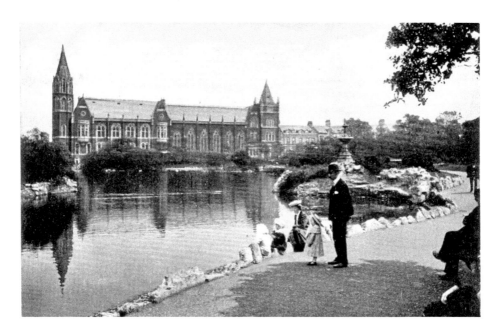

Mowbray Park and Victoria Hall

A postcard showing Mowbray Park and the Victoria Hall around 1908. The grounds on which this section of the park stands were bought from The North East Railway Co. and the park extension opened on 10 July 1866. The hall, purchased by the council in 1903, was extended at a cost of £30,000 and re-opened 7 November 1906.

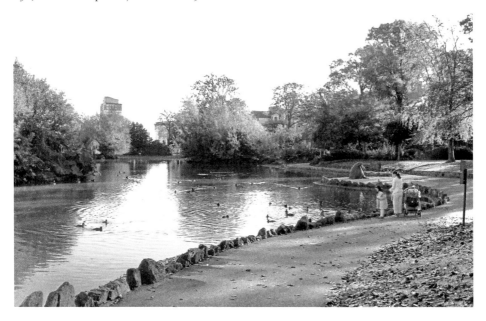

The restoration of Mowbray Park began in 2000 and Queen Elizabeth II formally opened the new 'Mowbray Gardens' on 7 May 2002. On the site of the old park fountain, a bronze walrus now stands (right centre) cast by artist Andrew Burton. As these two images show, children love the park today as much as they did in years past! Mowbray Gardens were voted 'Britain's Best Park' in 2008. A German parachute mine destroyed the Victoria Hall on 16 April 1941.

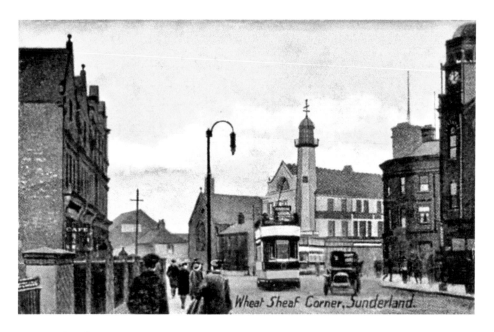

Wheat Sheaf Corner

A picture postcard of Wheat Sheaf Corner taken from North Bridge Street around 1908. Note that the tramcar has no 'Shop at Binns' advert on its frontage - this did not become a common sight until around 1924. To the left is a café. After Southwick Road the church of The Venerable Bede (1870), the Lighthouse Stores, the Wheat Sheaf Hotel (1897/98) and Sunderland Corporation Tramways and Motors Offices can be seen. The lighthouse was a wooden replica of the octagonal lighthouse on the old north pier.

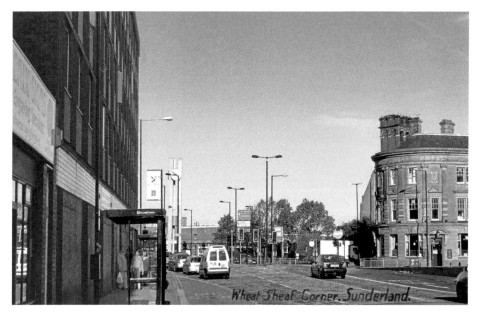

Only the Grade-II* listed Wheat Sheaf Hotel now remains at this scene, but behind the hotel on Roker Avenue is a glimpse of the Miners Hall of 1894 (architect J.W. Bell). Whilst undergoing demolition in 1970, a fire destroyed the Lighthouse Stores on 5 November!

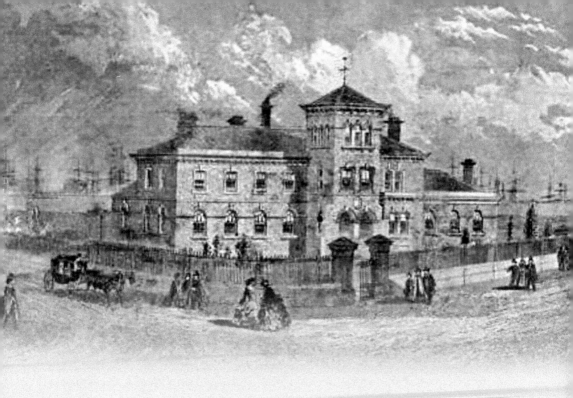

chapter 2

The East End

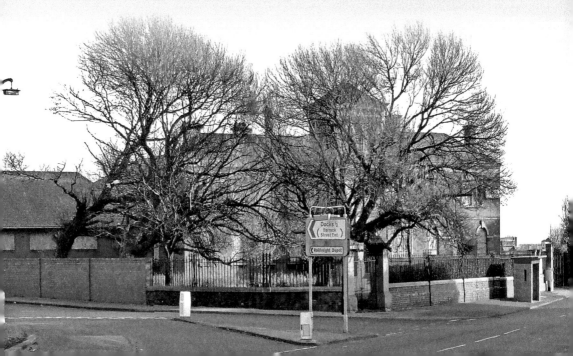

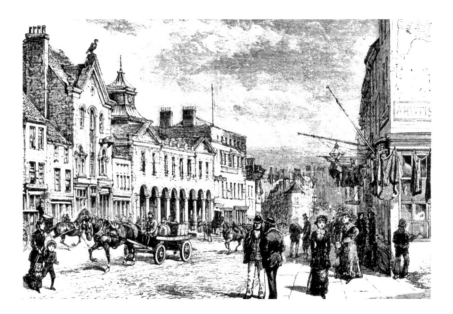

High Street East

A wonderful print that appeared in the *Graphic Illustrated Weekly* newspaper on 3 February 1883. The Exchange Building (centre left) was erected between 1812 and 1814 and was Sunderland's first town hall. The adjacent Eagle Tavern structure dates to 1869, but inns are said to have been on this site from the seventeenth century. 'Artistic licence' seems to have been used in this sketch. The tavern eagle has been given folded wings and only eight windows and arches are drawn into the Exchange Building!

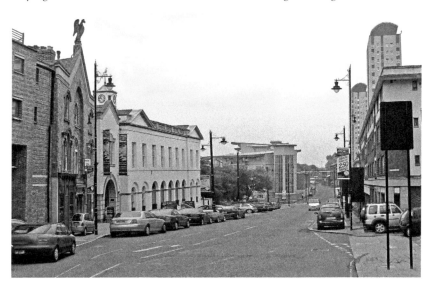

The Exchange Building was refurbished in 2002 at a cost of £4.5 million and is now The Quayside Exchange – a conference and restaurant venue. The Eagle Tavern, also restored at this time, contains a range of business units and is known as the Eagle Building. A replica of the original eagle was installed on its apex during restoration. The new Riverview Apartments (centre right) now sit opposite the fish quay. Far right is Bodlewell House, beyond which are the Lambton and Lumley Towers.

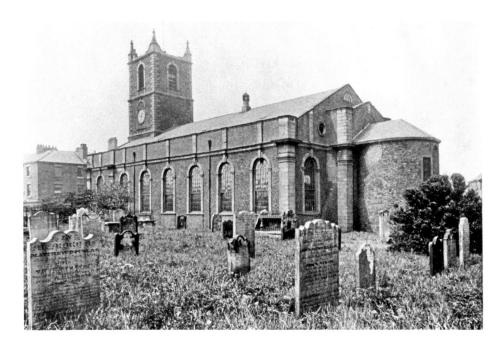

Sunderland Parish Church

Sunderland parish church – Holy Trinity, was erected in 1719 on a parcel of land called the 'in tack'. Its designer was W. Etty and the church was consecrated on 5 September 1719. The church also housed the town's first council chamber and library. Notable people in Sunderland's history are buried here including Rector Robert Gray, John Dixon and Jack Crawford. The last person to be interred in its graveyard was Mary Rogers in January 1901.

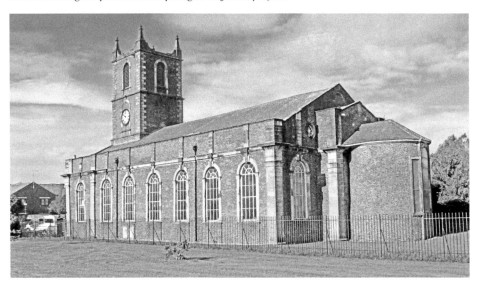

Over 100 years separate these two photographs, but little of the structure has changed in this time, except for the 'laying down' of most of the headstones for reasons of safety. The gravestones of the three gentlemen mentioned above however, survive intact. Congregation numbers dwindled as the East End community was dispersed across other areas of Sunderland and the last services were held here on 26 June 1988. It is now owned by The Churches Conservation Trust.

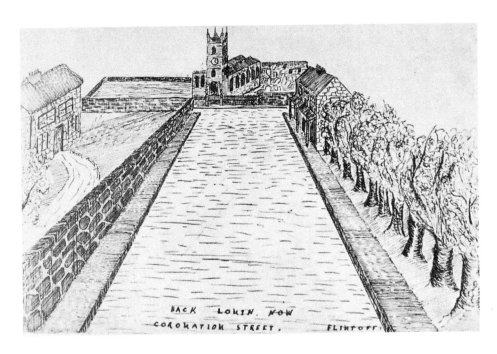

Coronation Street

An early Flintoff print showing how the easterly end of Coronation Street looked before its Georgian houses were erected in 1820. At the time of this sketch it was known as the Back Lonnen. Prominently in view are Sunderland parish church of 1719 and its graveyard. Coronation Street took its name from the development of the easterly part of the lonnen in time for the crowning of George IV on 29 January 1820.

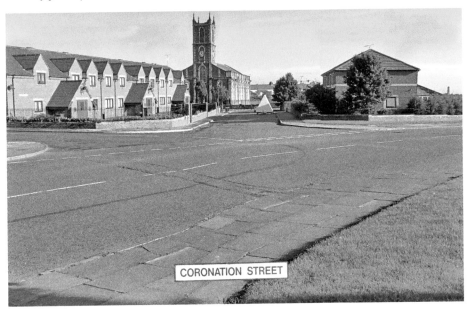

Parts of Georgian Coronation Street survived into the 1970s. This present view shows a row of modern houses built on the line of the easterly end of the old street, which is part of Trinity Square. Inset: a contemporary street sign.

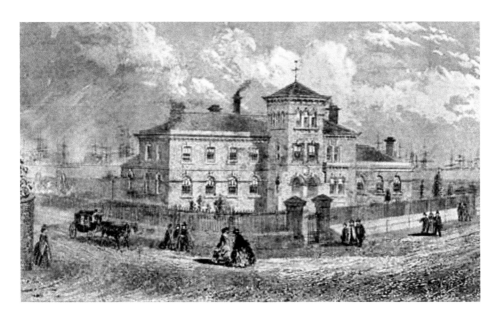

The Boy's Orphanage, Sunderland

A wonderfully animated Victorian engraving of the 'new orphan asylum' by M. and M.W. Lambert. It was built to house and educate those boys whose fathers had been lost at sea. Architects for the orphanage were Childs and Lucas and it was erected in 1861 under the supervision of Thomas Moore. It is said to have been modelled on Osborne House, the Isle of Wight residence of Queen Victoria. To the far left is a glimpse of the churchyard wall of Holy Trinity. *Image (C591) reproduced by permission of the Librarian, Robinson Library, Newcastle University.*

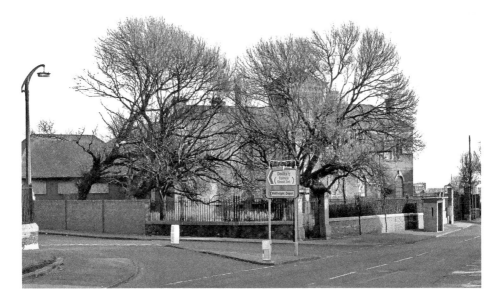

This modern view shows that an extra storey has been added to the right hand side of the building. In recent years the orphanage has been used as a community centre, but this wonderful structure may one day be restored and properly recognised as one of Sunderland's finest buildings. The orphanage was home to the author's great grandfather, following the death at sea in 1867 of his father, a master mariner.

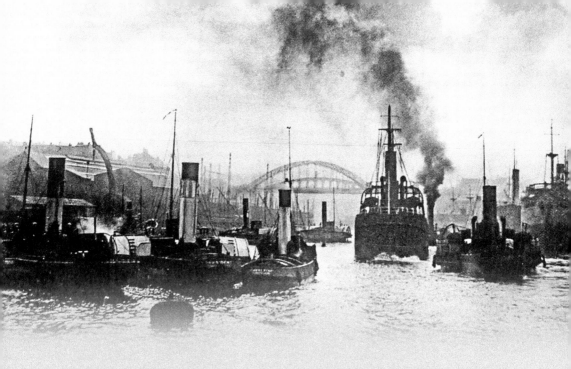

chapter 3

The Docks and the River

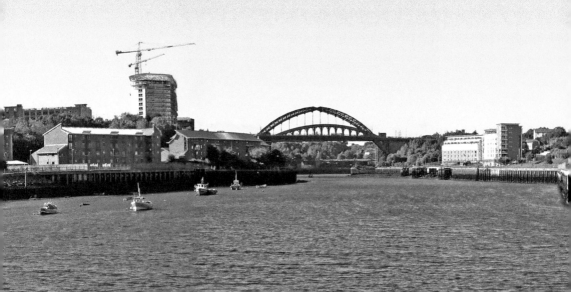

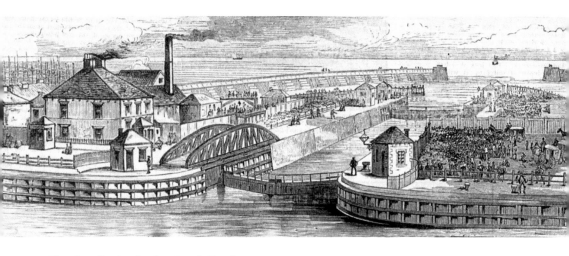

The Sea Outlet in the South Docks

This is a drawing that appeared in *The Illustrated Evening News* (I.E.N.) on 30 October 1880. The I.E.N. reported at the time: 'A new lock and deep water channel recently constructed at the sea outlet of the south docks at Sunderland were opened on Thursday week by the Earl of Durham, who ships vast quantities of coal in the port. The works thus inaugurated, form an important part of an extensive scheme of river, dock, and harbour improvements planned by Sir John Coode and estimated to cost more than half a million sterling, which are being carried out by the River Wear Commissioners.' One of Lord Durham's steamships, the Lady Beatrix can be seen out at sea and about to enter the new lock as a commencement to the opening ceremony. After the official unveiling, a luncheon took place in The Laing Warehouse for all the invited guests.

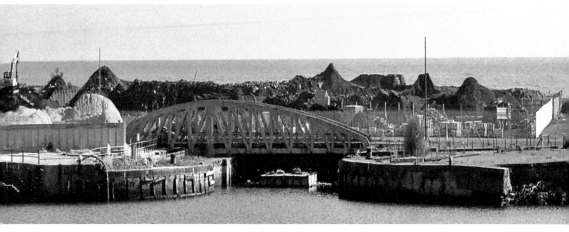

As this modern photograph was being taken in 2006, a land reclamation scheme was taking place around the deep-water channel, between dock and sea.

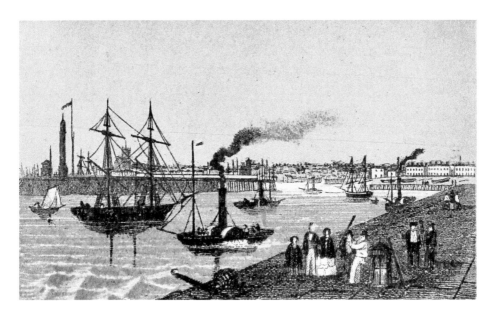

Sunderland from the Old North Pier

A Rock & Co. print of a busy river estuary that dates to around 1860. The old south pier and lighthouse can be seen to the left. St. John's church is visible through the rigging of the sailing ship. Shipbuilding is taking place on Monkwearmouth Shore and just beyond the Potato Garth is Sand Point. Meanwhile, a choppy sea has not deterred the locals from a saunter along the pier!

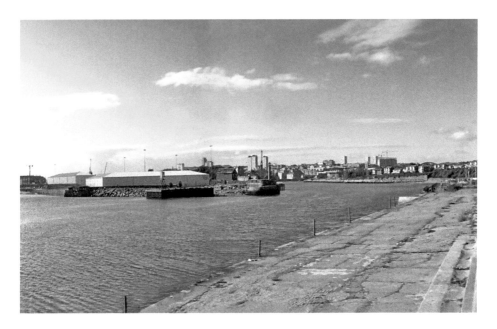

The same view today certainly looks somewhat quieter! St. John's church was demolished in the early 1970s. The National Glass Centre, which opened 23 October 1998, can be seen on the north shore (centre right). The Echo 24 development scheme is still under construction in 2006.

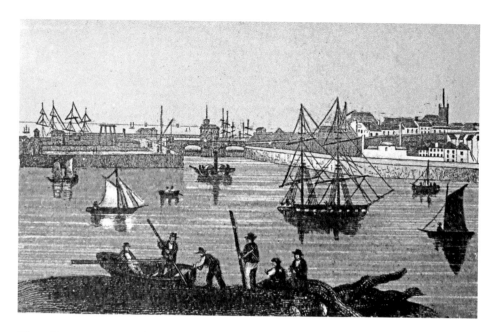

River Entrance to South Docks

Another Rock & Co. print of around 1860. John Murray's Head Dock Office is visible (centre left) beyond the river estuary entrance to the dock itself. To the left is a berthing area that on old maps is called the Polka Hole. To the far right, St. John's church, which was built in 1769, can be seen above what is likely to be North Moor Street – the Pottery Buildings of 1868 were yet to be erected. In the foreground, what appears to be a 'ferry service' is in operation.

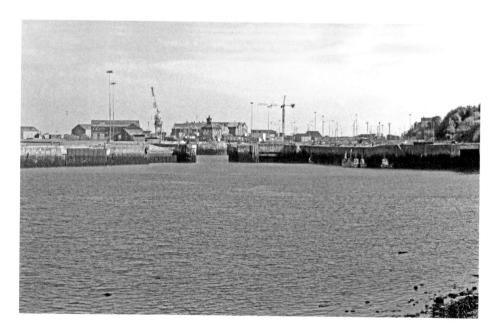

Again, how quiet the same view looks today. The Gladstone Bridge of 1850 can be seen better on the modern view than on the 1860 sketch.

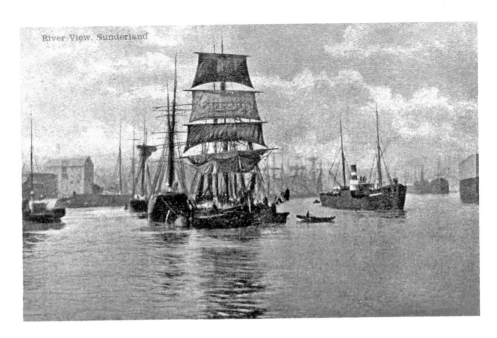

River View

A sailing ship unfurls its sails and prepares to leave the port in this lovely postcard view of around 1903. Two steam vessels and a foyboat lie close by. The town's bridges are hidden behind the host of ships berthed on the river. Old Wylam Wharf (left) was acquired by Edward Wylam in 1819. Its central location made it one of Sunderland's busiest wharves, trading in coal and general goods. Its old bonded warehouse can be seen to the left of the picture.

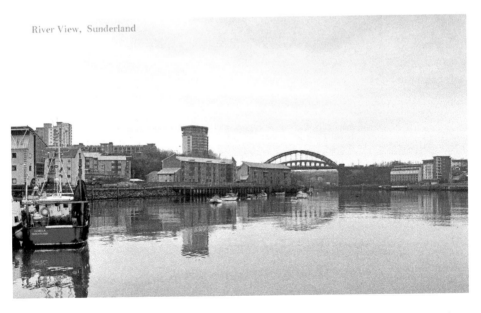

River View, Sunderland

The bonded warehouse, now Grade-II* listed and called the Roseline Building, was saved from dereliction in 1995. It houses five office suites and a busy restaurant. The fishing boat *Isabella* is moored nearby at the fish quay, but there is no problem spotting the bridges from the same viewpoint today!

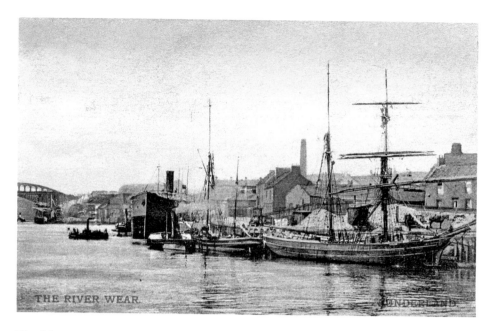

The River Wear (1)

A fine view of around 1904 looking across the river to Monkwearmouth from a similar viewpoint as the previous picture. Sailing ships and steamers lie at quays along the north shore. Four industries were operating along this stretch of the river at this time – (left to right) a sawmill, brewery, engine works and a ship repair works.

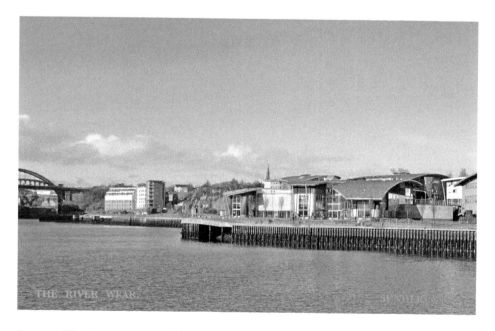

St Peter's Wharf apartments and the university campus occupy this part of the riverbank today. The steeple of the Grade-II* listed Hebron church (1891-92) formerly the Free Church of Scotland (Presbyterian) can now be seen on the horizon from this standpoint.

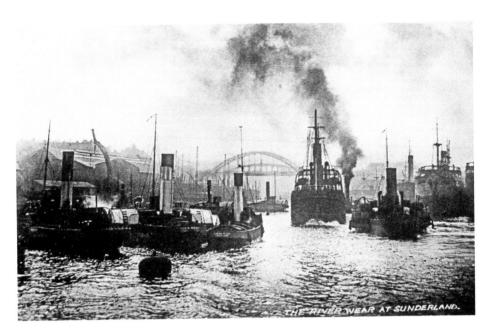

The River Wear (2)

What a bustling smoky river the Wear was in its industrial heyday! This evocative 1930s postcard view is a reminder of Sunderland's proud industrial heritage, when we were still able to call ourselves the 'largest shipbuilding town in the world'.

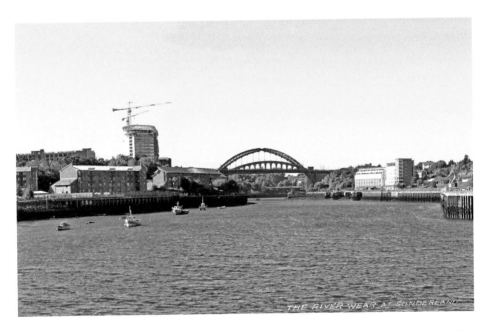

How different our modern riverside looks today. On the south shore (left), university student accommodation lies at the river's edge below the towering Echo 24 development. On the north shore (right) is another view of St. Peter's Wharf apartments at Bonners Raff.

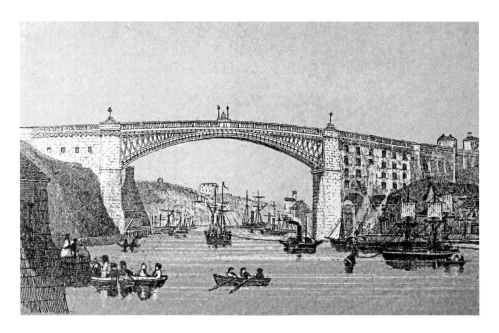

The Wear Bridge(s) from Pann's Ferry

This sketch by Rock & Co. indicates that there was still abundant trade available for the Pann's Ferry after the opening of the town's bridge. The structure featured is Robert Stevenson's reconstructed 'flat-deck' road bridge of 1859. A cone from the glassworks can be seen close to the abutment on the south side (left) of a busy river.

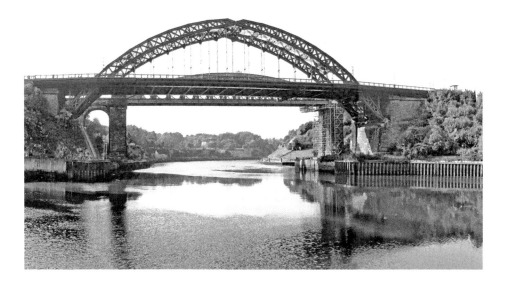

The Wearmouth Bridge of 1929 and the hog back rail bridge of 1879 now dominate this view. In contrast to the old print above, the river, no longer a busy industrial highway runs quite peacefully.

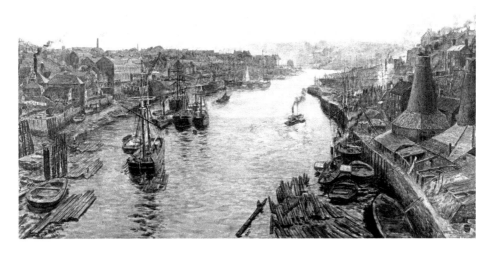

The River Wear from the Bridge

A wonderful painting of 1882 by Thomas M.M. Hemy, which shows Sunderland at its industrial peak. On the north bank of the river (left) Wilson's Saw Mill, Monkwearmouth Brewery and Dickinson's Marine Works can all be seen. On the opposite bank, Pann's Bottle Works are visible and tugs 'raft' timber together on the river. (Painting courtesy of Sunderland Museum and Winter Gardens, Tyne and Wear Museums).

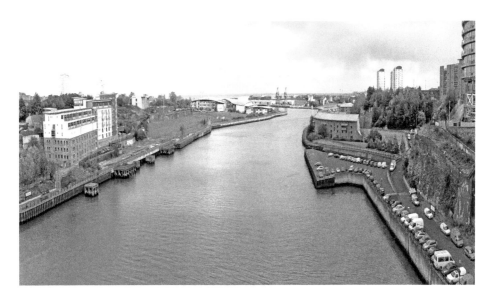

Very little evidence of industry is apparent today. On the north bank (left) are St. Peter's Wharf apartments with the university campus beyond. On the south bank in the distance, the two cranes at the Port of Sunderland can be seen, next to which stand two of our oldest surviving pubs, the Boar's Head and the Clarendon with its Bull Lane Brewery. The Echo 24 riverside apartment block is just visible to the top right of the picture.

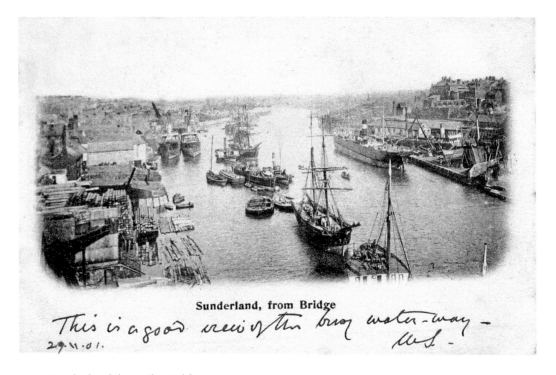

Sunderland, from Bridge

This is a good view of the busy water-way -
29.11.01. *W.S. -*

Sunderland from the Bridge
A slightly later view of the river on an early picture postcard that dates to around 1901. Visitor W.S. remarks on how busy the waterway looks to him!

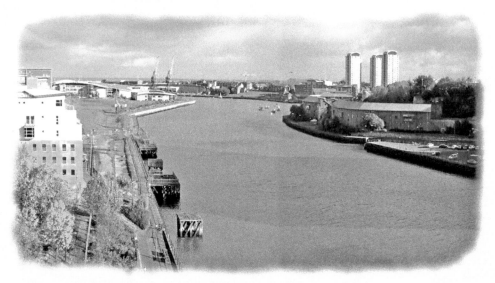

Another good view of this now 'not so busy' water-way -
01.11.2006 *K.C. -*

Author K.C. revisits the same scene today and comments how tranquil the river looks in 2006!

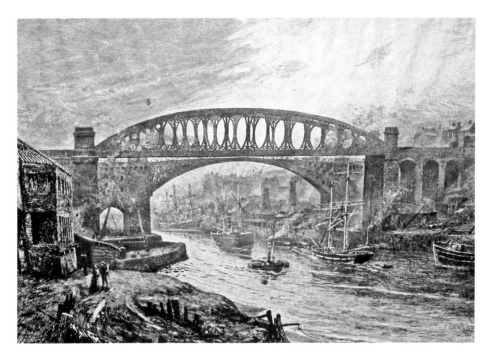

An East View of the Bridges

A dramatic 1893 etching of the Wear Bridges by Thomas M.M. Hemy. Print sellers Hills & Co. first published it on 1 September 1893, but the etching may have come from an earlier painting by the artist of 1882.

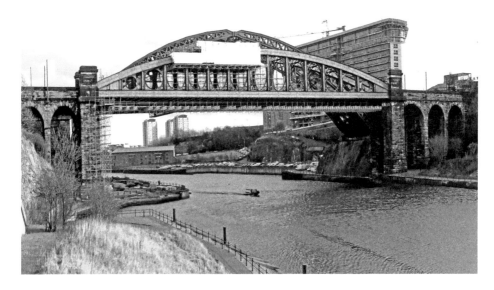

The modern picture shows the renovation of the 1879 rail bridge that took place in 2007 – the first major refurbishment since it was erected. Just behind the bridges (right), the Echo 24 development nears completion.

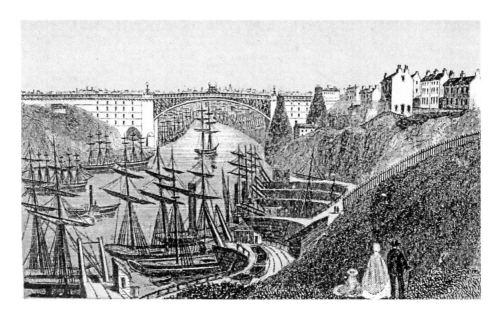

The Lambton Staiths

Another accurately dated print from 1st February 1862 from Rock & Co. looking eastwards. The coal staiths date to 1812–1815 with the development of the Newbottle Railway. Seven years later, John Lambton owned them. In the foreground sea going colliers are loaded with coal. The road bridge of 1859 straddles the river. Beyond the bridge, sailing ships are berthed on the north shore, whilst vessels are under construction on the south side.

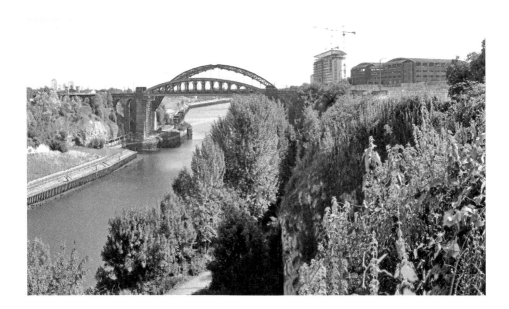

The rail and road bridges of 1879 and 1929 now sit astride of the river. St. Peter's Metro Station (upper left), the Echo 24 apartment block and St. Mary's car park (upper right) can all be observed. The staiths closed on 4 January 1967 – coal dust no longer permeates the air in this vicinity!

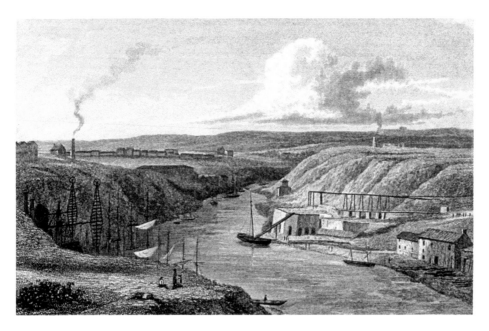

The River Above Sunderland Bridge

An engraving from a William Westall drawing produced for his book *Great Britain Illustrated*, which was published in 1829. On 20 March 1815 rioting keel men fearing for their livelihood, pulled down the new rail bridge across Galley's Gill and set fire to the staiths (left). To the right limekilns, which were served by a waggonway from the quarry at Fulwell take coal from a keel on the river.

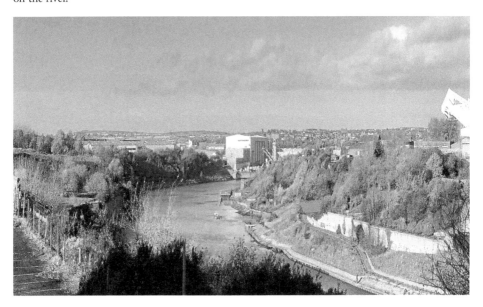

As the export of coal from Sunderland gradually increased, the Lambton Staiths were much expanded over the years but after the final coal shipment of 1967, the area was landscaped to create a public park area. Specialist crane manufacturer, Liebherr, can be seen (centre right) operating on the river's edge at the former Laings shipyard site. The Stadium of Light (far right) opened on 30 July 1997 on the site of old Wearmouth Colliery.

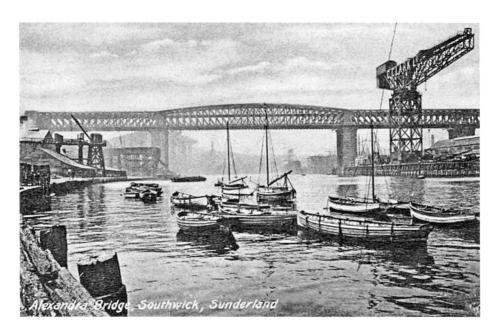

The Queen Alexandra Bridge

Another postcard view of a river scattered with small craft. On the left and right beyond the bridge are Doxford's and William Pickersgill's shipyards respectively. At the front of the bridge (right) are George Clarke's hammerhead crane and Marine Engine Works. The Queen Alexandra Bridge was built as a double decked rail and road bridge and opened on 10 June 1909.

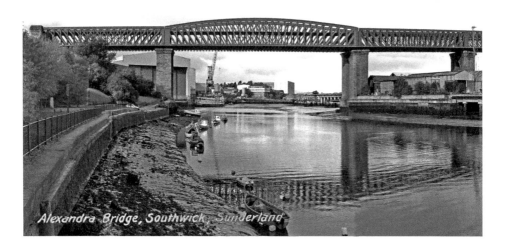

Doxford's covered shipbuilding hall (left) was the largest in the world in the 1970s. Berthed next to the hall in 2006 is the Irish ferry, *Manxman*, which was towed into the hall (now Pallion Engineering) from the river for a hull survey shortly after this picture was taken. In 1954, the yards of Austin's and Pickersgill's merged to concentrate on work here at Southwick. This merged yard closed in 1988. By 1920, the upper rail deck of the Queen Alexandra Bridge was almost redundant due to a decline in the coal trade.

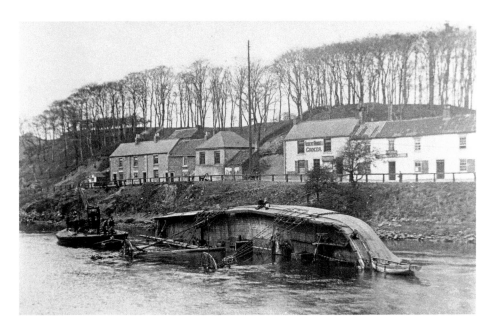

North Hylton

An intriguing photograph that shows the capsized sailing ship *Danube* in the river at North Hylton in April 1898. As the ship was being repositioned to allow a passenger steamer to pass by, the receding tide caused the brig to overturn. Onshore centre right is the grocery shop and post office of Robert Riddell. Adjacent to it is the seventeenth-century Shipwrights Arms, an old coaching inn.

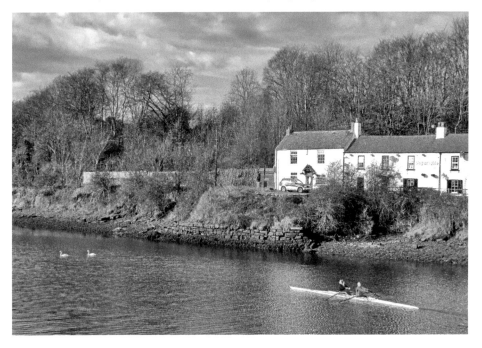

Another ebb tide view of the river in February 2009. The buildings to the left of the picture no longer survive, but the former grocery shop is now called White House Cottage. The Shipwrights Arms still operates today.

Hylton Ferry

An evocative view of Hylton ferry reproduced from an old Victorian lanternslide. A lady passenger stands for the ferry crossing, but the small boy is more interested in what is going on in the water! The vehicular chain operated ferry lies at the river's edge (lower left). The original Golden Lion – another old coaching inn, can be seen centre view.

Much has changed on this modern photograph. The 'key feature' used to frame it was the ferry steps (right). The Golden Lion was rebuilt around 1910, but an old date stone of 1705 (inset) can still be seen above the doorway.

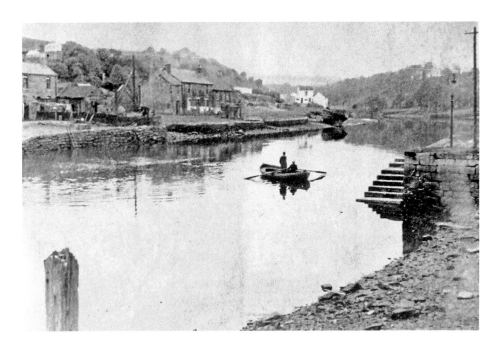

Upriver from Hylton Ferry

A photograph taken around 1946, looking upriver from the north bank below Hylton ferry. Standing for the ferry crossing must have been the thing to do! The berthed hull of an old wooden vessel lies on the south river bank upstream of the ferry.

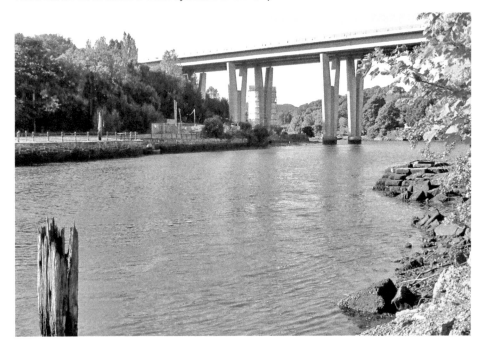

The A19 Hylton road bridge (1970-74) is prominent on the modern picture. Although the north ferry steps survive, the quay complete with its gas lamp has gone. Amazingly, the wooden post (lower left) has survived!

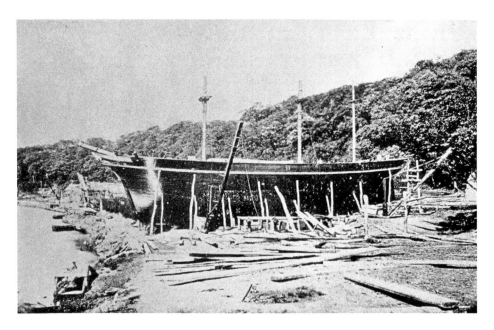

Bartram's Shipyard at South Hylton

An interesting view of a sailing ship under construction at Bartram's Yard at South Hylton sometime before 1871. It is thought that George Bartram worked here as early as 1837.

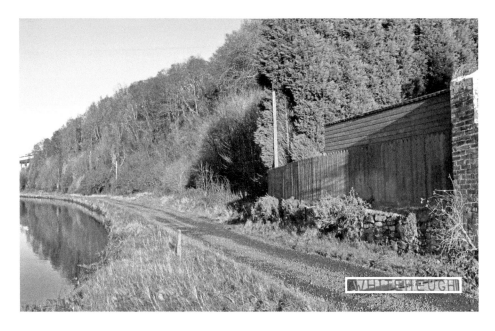

This photograph is different to all others in this book, in that I have used a written description of where the shipyard was sited to frame the modern view. Bartram's Yard is said to have been located '100 yards to the east of Garden House at Whiteheugh'. A glimpse of Hylton Bridge (far left) may help the reader to identify the location. Garden House and its adjoining property Whiteheugh (see inset) still survive today (off picture right). Bartram's relocated to Southwick in 1871 when the production of iron ships began in earnest.

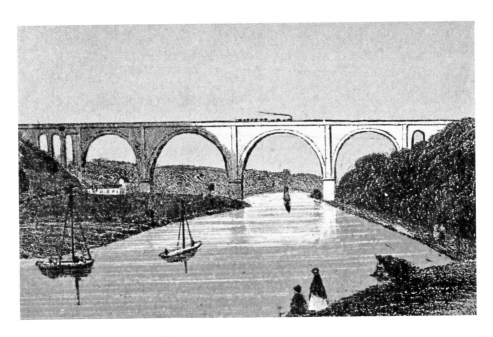

The Victoria Viaduct, Washington

A Rock & Co. print of the Victoria Viaduct that dates to 20th March 1858. It was completed on Coronation Day, 28th June 1838, hence the name that it was given. The inspiration for its design by Walker and Burgess came from a Roman bridge built by Emperor Trajan in Alcantara, Spain around AD 105. Stone from the local quarries at Penshaw was used in its construction. Keelboats can be seen taking coals from the staiths at Washington down to the river mouth at Sunderland for transport to London and the Low Countries.

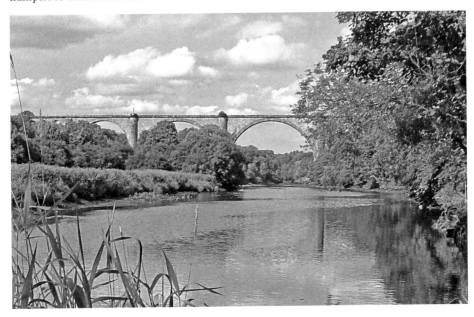

The bridge is now thought to be one of the most impressive stone viaducts in the country and is one of the wonders of early railway history. Until its closure in 1991, it was said to be the oldest rail bridge still in use in England.

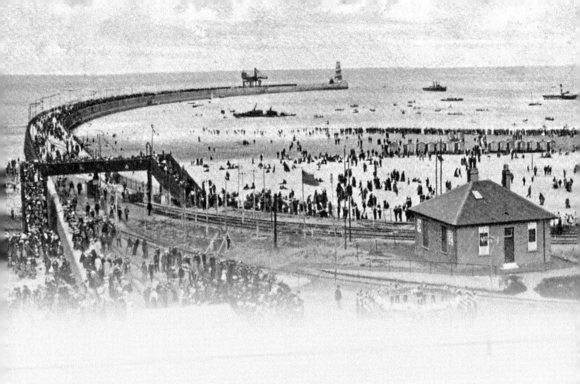

chapter 4

The Seaside

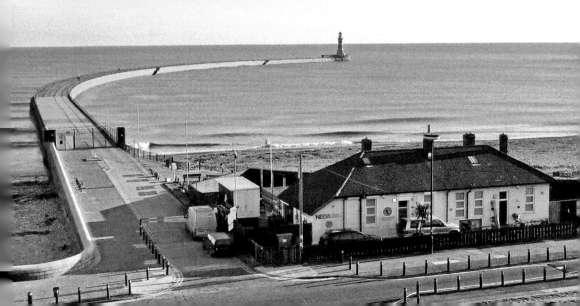

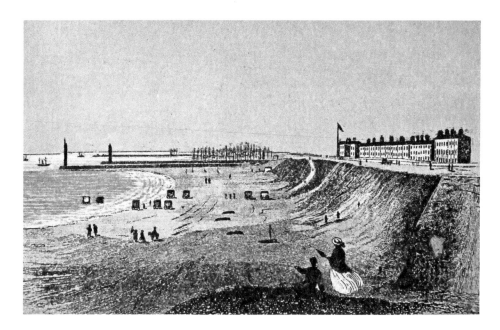

Roker Beach

Another splendid, accurately dated Rock & Co. print of 12th February 1858 looking south along Roker beach and drawn from the viewing perspective of Battery Point. It was a somewhat breezy day judging by the lift of the lady's skirt in the foreground! To the left, the old north and south piers can be seen. Changing booths, hired to protect the modesty of the Victorian lady bathers are evident along the shoreline. To the right, is Roker Terrace, designed for the Abbs family around 1840 by John Dobson.

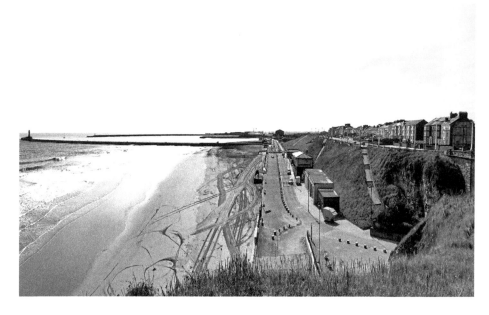

The Coastguard's Station now stands at the same vantage point for this modern view. The north pier of 1903 can be seen to the left. No road existed north of the Roker Hotel before Roker Ravine was bridged in 1880 (see far right).

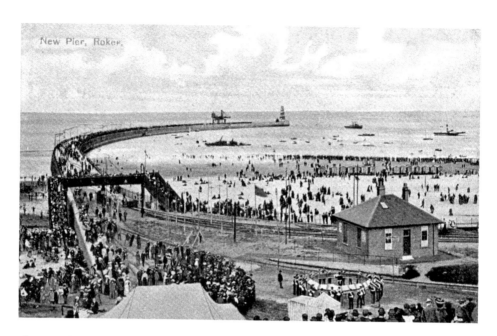

The North Pier, Roker

Although franked for 1906, this postcard shows the official opening of the North Pier at Roker on 23 September 1903. The band of the Northumberland Hussars (lower right) entertained a large crowd of VIP's and spectators throughout the ceremony and Lord Durham formally opened the pier by setting the final stone into place. Work on the £290,000 breakwater had begun some eighteen years previously.

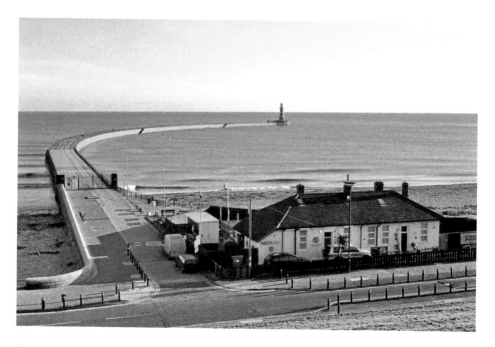

In contrast, things look very quiet around the pier in January 2009! By 1916, the associated pier buildings (lower right) had been further extended to look the way they do today.

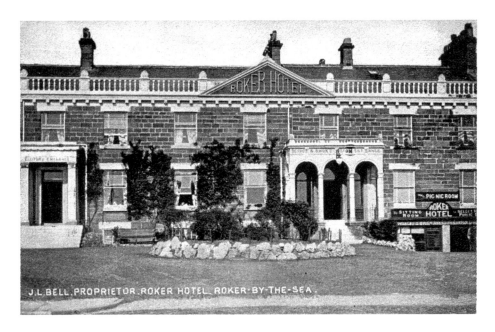

The Roker Hotel

The Roker Hotel on Roker Terrace pictured in around 1910. To the left, is the 'visitor's entrance' with the 'buffet and smoke room entrance' centre right. Far right is the 'picnic room, sitting room and public bar' where 'stable and cycle accommodation' is offered. The hotel and its associated baths opened in 1842.

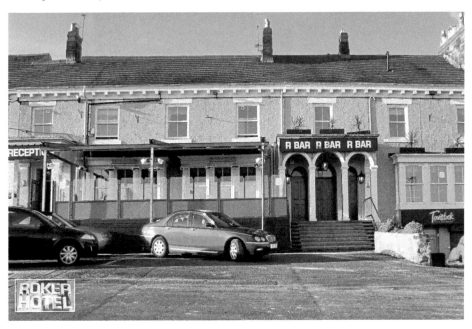

The hotel, which was refurbished in 2004, still operates under the same name today (see inset). The basement room to the far right is now an Italian restaurant. The author well remembers the ever-popular 'three course special' at the Roker Hotel in the 1970s – prawn cocktail, steak and chips followed by Black Forest gateau. What a treat!

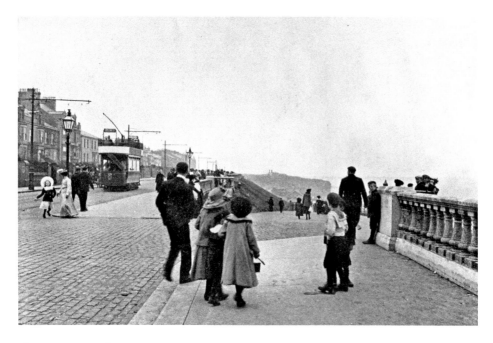

The Terrace, Roker

A charming early Edwardian photograph looking along Roker Terrace around 1904. An open decked electric tramcar has just passed the Roker Hotel. Pedestrians seem to have dressed in their best clothes for their walk!

The demolition work carried out on Holey Rock in the mid-1930s means that from this vantage point, we are now able see some of Roker Cliffe Park and catch a glimpse of Thomas Meik's lighthouse of 1856, which was placed there in 1983 when the old south pier was shortened.

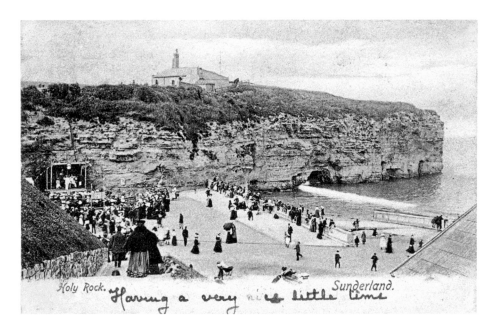

Holey Rock, Roker

An extremely animated view of the Holey Rock area around 1903. The 'Jumbles' are on stage performing their 'Pierrots Show' to a crowd of holidaymakers. This area was called Hole Rock or Hole Point in older times. Roker Battery (top centre) stood here from Napoleonic times and was known as Smithson's Battery at the turn of the nineteenth century.

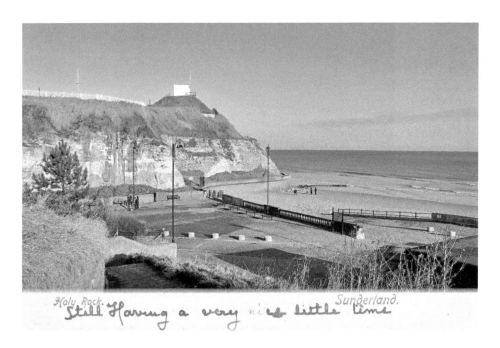

On a sunny morning in January 2009, exercising the dog seems an attractive proposition for a few of the locals. Safety concerns resulted in the demolition of a large proportion of the rock in 1936. A modern 'coastguard lookout' facility now resides on the top of the cliff.

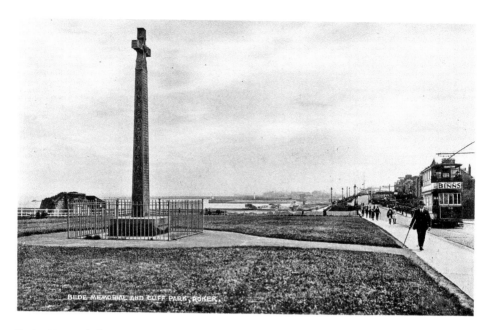

Bede Memorial Cross, Cliffe Park

A brisk walk along Roker Terrace seems to be the order of the day for the gentleman with the walking cane. The Bede Memorial Cross was the work of Charles Clement Hodges and was carved from stone obtained from the private quarry of Lord Armstrong at Cragside in Northumberland. The cross, depicting scenes of some of the striking incidents recorded in the story of Bede's life, was unveiled by the Archbishop of York on 11 October 1904. It was removed during World War One for safekeeping and was restored to its site in 1921 – a task that was repeated once more in World War Two before finally being reinstated in April 1949.

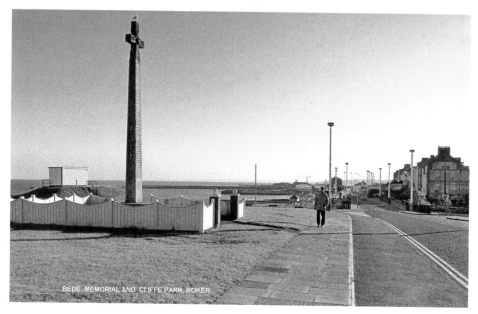

In 2006, modern road widening schemes have brought the passing pedestrian closer to the memorial and a seagull enjoys the November sunshine perched on the top of the cross.

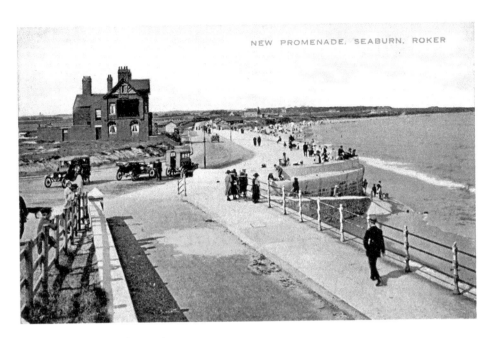

The New Promenade, Seaburn

A lovely postcard view of the New Promenade at Seaburn that dates to around 1920. Work on the new 'prom' and sea wall was completed in 1918. The old narrow road to Whitburn however, was still in place adjacent to the promenade. Seaburn Café can be seen to the top left of the picture.

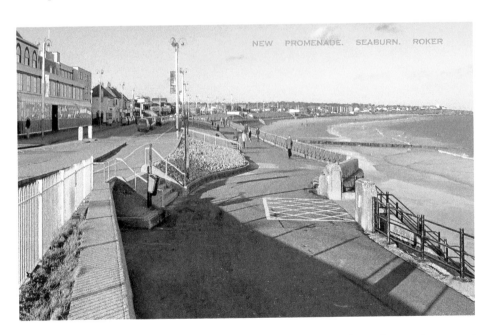

Seaburn Café was demolished around 1930 as schemes to develop the seafront and new road system got underway over the next two years. Plans for a hotel to be constructed near to the 'café site' were passed in 1936 and today the Marriott Hotel operates here. Beyond the hotel are a pub and a variety of Indian, Italian and Chinese restaurants. Note the changes to the promenade for the construction of steps onto the beach (right foreground).

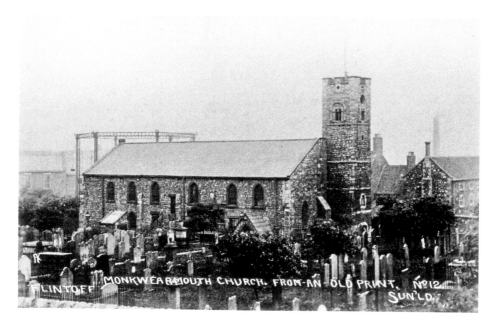

St. Peter's Church, Monkwearmouth

A Flintoff print of the parish church of St. Peter that dates to sometime between 1866 and 1874. The church stands on the site of Benedict Biscop's monastery of AD 674. Indeed the existing west wall of the church nave and the porch (right) were part of this ancient monastic building. The upper portion of the tower is pre-conquest in date. The fourteenth-century doorway (lower centre) survived a radical restoration of the church between 1866 and 1874 by architect R.J. Johnson.

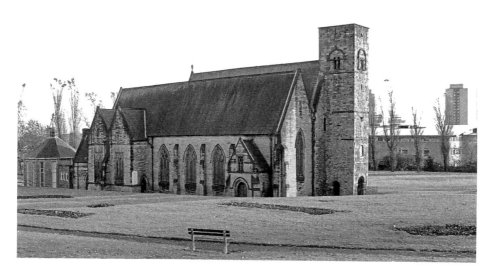

In 1984, parts of the interior and roof of the church were rebuilt following a fire. The twin monastery site of St. Peter's at Monkwearmouth and St. Paul's in Jarrow is the UK's nomination for World Heritage Site status in 2010.

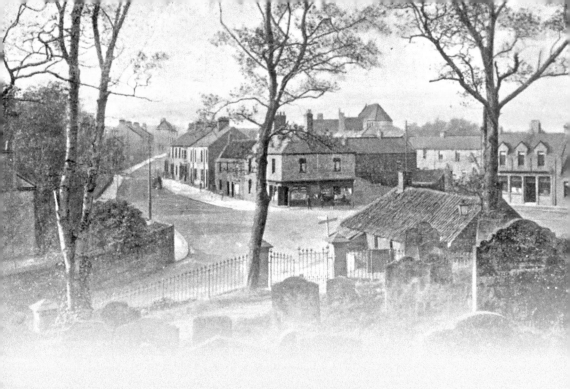

chapter 5

Out and About

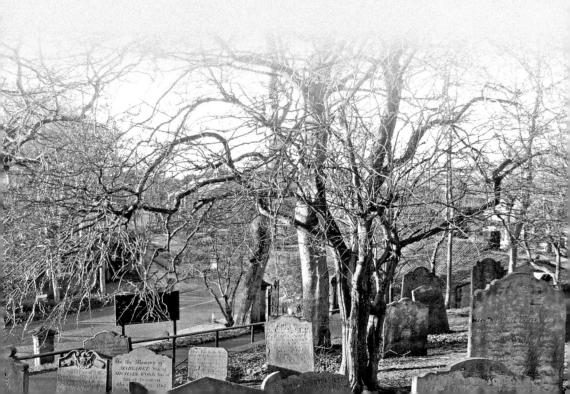

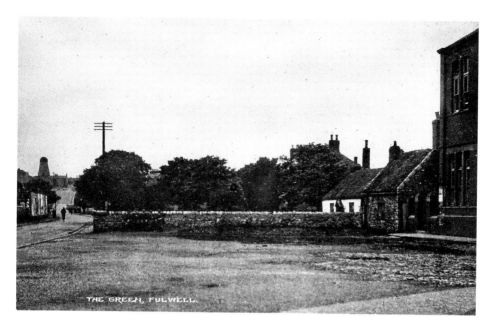

The Green, Fulwell

A lovely old view of The Green at Fulwell, which dates to sometime in the 1930s. A lone cyclist rides up Station Road towards Fulwell Mill (left). To his right, five gentlemen sit on a bench on the edge of green with all the time in the world to spare! Far right is Fulwell Infant's School, which was built in 1877 and demolished a century later. Next to the school is Ferry's Dairy Farm, which was badly damaged in a bombing raid in World War Two.

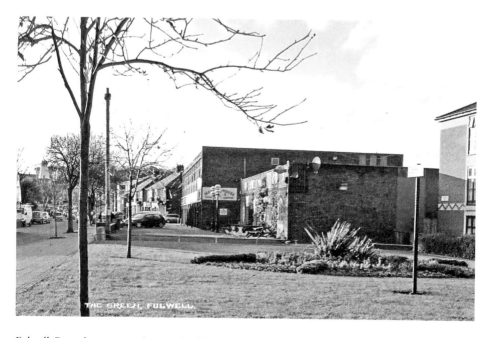

Fulwell Green has more or less survived intact. Peter Stracey House, a sheltered housing apartment block now stands on the site of the old school. Until recently Windmills P.H. traded on the site of Ferry's Farm but it is now closed and a veterinary surgery operates there.

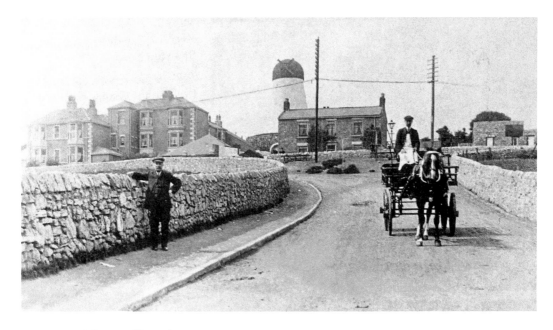

Fulwell Mill from Mill Bank

Another evocative image of old Fulwell taken from Mill Bank in the 1930s. Prominently placed in the picture is Fulwell Mill, which was built in 1808 for Joseph Swan at a cost of £900. It closed as a working mill in 1949 after being in the hands of the Moody family for almost seventy years. Ivy House (to right of mill) was the home of 'part time' miller James Simpson in its last working years.

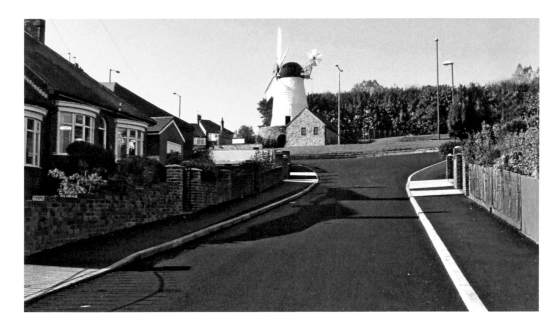

Bungalows now sit at each side of Mill Bank here but the line of the street remains the same. The mill was taken over by Sunderland Corporation in 1951. It was given dummy sails and a new cap in 1955. Ivy House was pulled down in 1958. Several houses to the left of the mill were also demolished. By 2001, the mill had been restored to full working condition at a cost of £800,000.

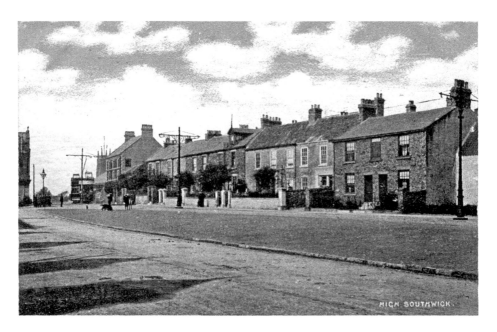

High Southwick

An electric tramcar makes its way onto Sunderland Road in this view of High Southwick that was taken a few years before the 'enclosure' of The Green in 1912. To the left of the tram is a glimpse of the Southwick Co-operative Store and to its right, the square tower of Southwick Holy Trinity church is visible. The church was built in the early English style in 1842 at a cost of £1800. What is probably Davison's Farm just makes it into the picture on the far right.

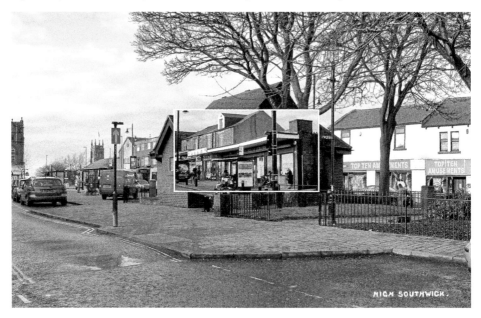

Southwick's public conveniences now sit bang in the centre of this view! I have therefore created an 'inset' to reveal what is now concealed when the scene is viewed from the same standpoint.

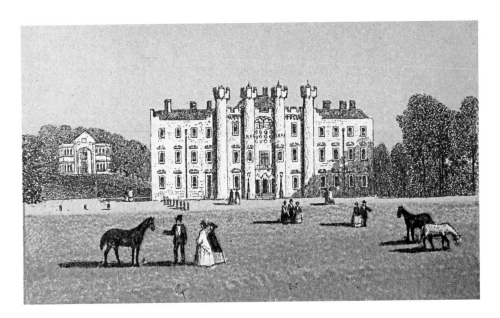

Hylton Castle

An animated Rock & Co. print of Hylton Castle dating to around 1860. The castle itself was built around 1400. The north wing was erected in the early 1700s and the south wing added some thirty years later. The Earl of Strathmore owned the castle at the time of this print, but the property was sold to William Briggs in 1863. St. Catherine's chapel can be seen to the left of the main structure.

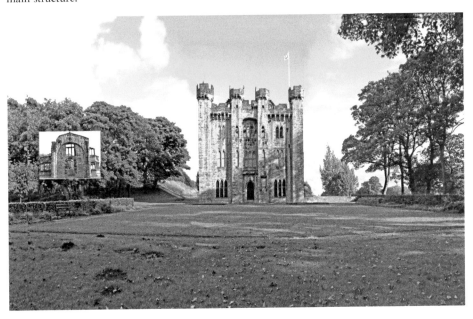

The 2006 view shows the castle without its wings – they were both demolished in 1869. The ruins of St. Catherine's chapel are shown as an inset as they are now hidden behind trees. Above the main castle doorway are the coats of arms of the families associated with the Hylton lineage. Among them are those of the Washington family – said to be the earliest known representation of the 'stars and stripes' on the American flag.

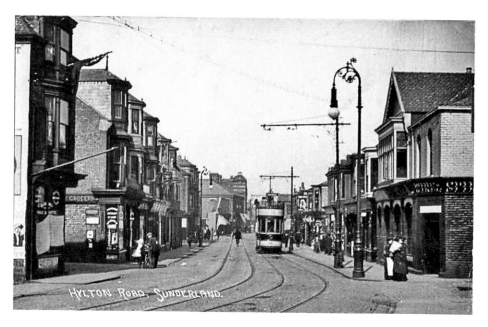

Hylton Road

A lovely postcard view of Hylton Road taken around 1910, in the days when electric tramcars were the main form of public transport. The Willow Pond P.H. (far right) stands at No. 173 Hylton Road. In the far distance (lower centre) at No. 150 Hylton Road is the Mountain Daisy P.H. by W. and T.R. Milburn, which was built in 1901.

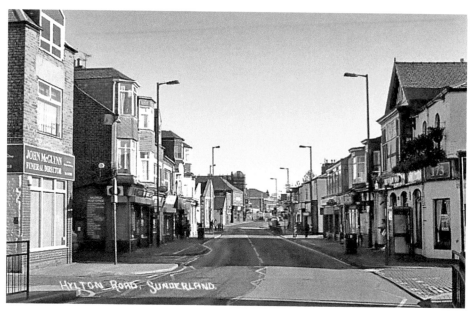

Today, the scene looks much the same, except for the absence of tramlines and ornate lampposts! Millfield Pentecostal church, (centre left) which moved here in 1964 is just visible. The two old traditional pubs survive today. The Mountain Daisy, now a Grade-II* listed building, still has its original bar. To the left, the grocer's shop became a post office (now closed) and a funeral director operates close by.

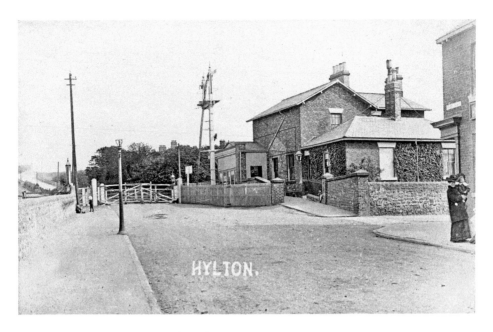

Hylton Railway Station, South Hylton

Hylton Railway Station and level crossing photographed in around 1902. The station opened in 1855, two years after the Penshaw Branch Line itself was available to passengers. Far right is a glimpse of the Railway Inn. The inn offered 'good stabling and accommodation for cyclists'.

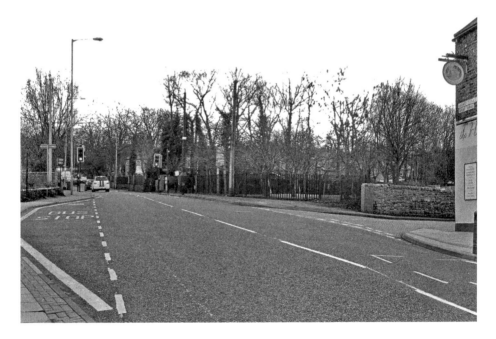

The railway station closed in May 1964 and from this viewpoint, all traces are gone, except for a portion of its boundary wall (right). The Railway Inn is now The Hylton P.H. To the left of the road (off picture) is South Hylton Metro Station, which opened in 2002. It has the longest platform of any station on the whole Metro network.

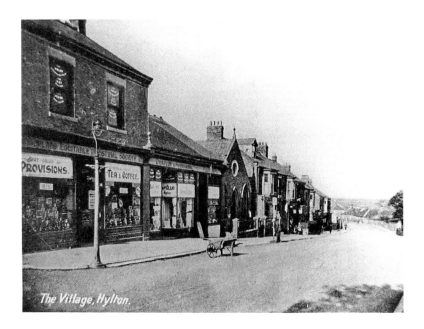

The Co-op, South Hylton

A photograph showing the Co-op on High Street, South Hylton in the early 1930s. The signage along the store reads 'The Sunderland Equitable Industrial Society'. There were three departments, namely, fruit and vegetables, drapery and provisions. Centre picture is the Independent Methodist church, which opened 23 August 1893. Gas lamps lit the street at this time – electricity did not arrive in the village until around 1935.

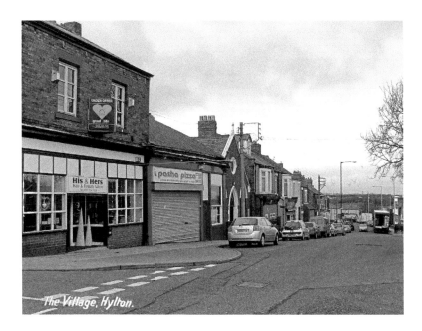

A hair and beauty shop and a pizza takeaway now occupy the old Co-op premises, but in December 2008, the building looks set to change hands once more.

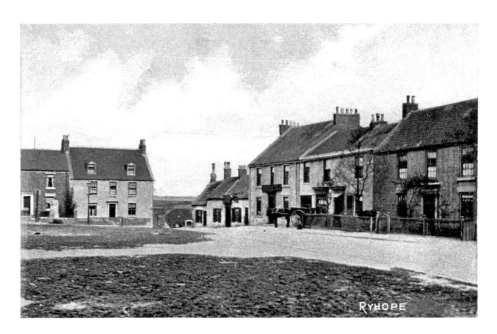

The Green, Ryhope Village

A view across Ryhope Green that shows how the village looked before electric tramcars ran through it. A corner of the Salutation Inn (left) was removed in 1905 to facilitate the laying of tramlines around the sharp bend in the road here. Further left, on the edge of the green, is the village drinking fountain and horse trough. Far right is Town Farm and adjacent to it are Watson's Butcher's Shop, the Albion Inn and the smaller Ship Inn.

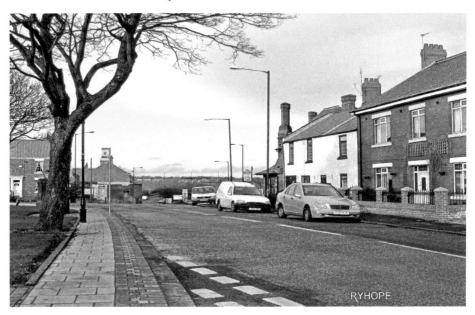

Intriguingly, the outer wall shell of the Salutation Inn is still standing today and its old doorway remains in place. Far right, is the red brick rebuild (1910) of Town Farm and the adjoining former butcher's shop is now a private residence. The Albion Inn is still present in its new guise, but the Ship Inn has long gone.

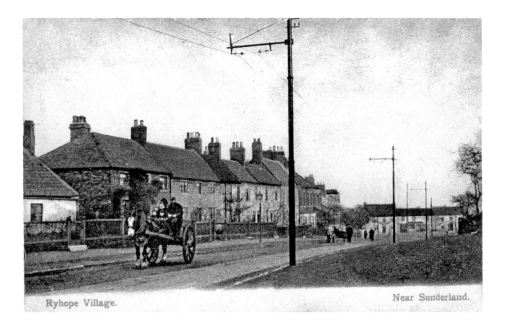

Ryhope Village. Near Sunderland.

Ryhope Village

In this view of Ryhope Village taken around 1907, the photographer appears to have captured dad on the school run! A resident tells me that the stone-built houses in the centre of this row date to the late eighteenth century. What appears to be Willow Farm just makes it onto the picture on the far left and we get another glimpse of the Albion Inn and Town Farm at the eastern end of the village (right).

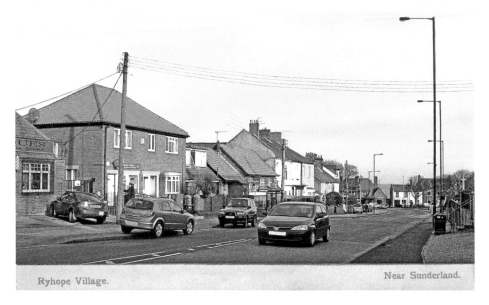

Ryhope Village. Near Sunderland.

A hair and beauty salon now operates in the modern building to the far left of the picture, but the village bank traded here before this. The adjacent red brick structure of 1937 houses the village post office. Adjoining the post office are two modern bungalows and the Village Tavern, which was formerly the Legion Club. The old houses beyond look to have survived broadly intact. 'Marlborough House' and a dormer bedroom of 'Woodlands' can still be observed from this viewpoint.

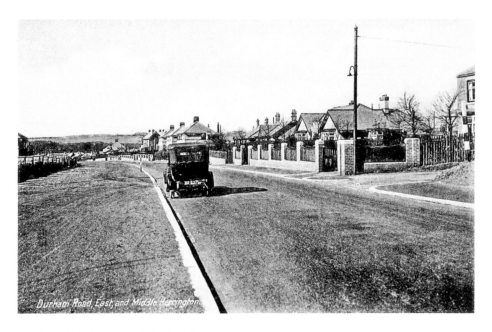

Durham Road, East & Middle Herrington

Another evocative postcard view, this time of Durham Road looking west and taken in the 1930s. New housing stands within a serene landscape that has quite a rural feel to it. To the right is Bridle Path. Tantalisingly, we are unable to see what buildings exist to the left of the road.

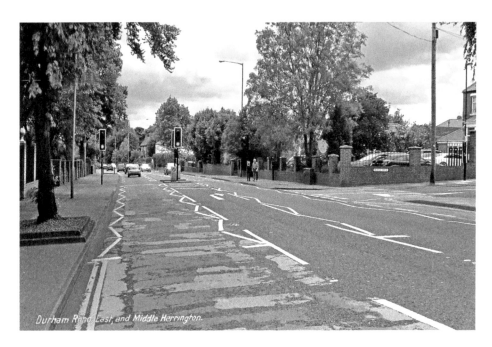

The modern image belies how hectic this road has become in recent years – I had to wait for a break in the traffic to capture today's scene, as the viewpoint is now in the middle of a wider, much busier road! Today, matured garden trees hide the lovely row of cottages and the house to the far right is a dental studio.

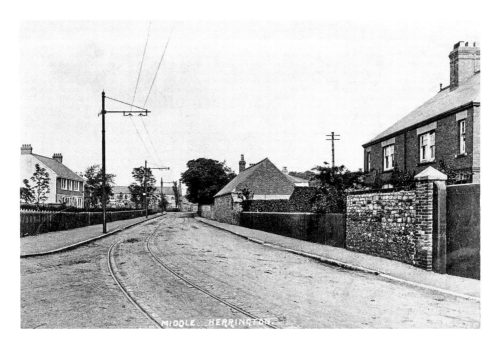

Crow Lane, Middle Herrington

A nice view of Middle Herrington looking along a 'tram lined' Crow Lane in the 1930s. Herrington Hall Cottages can be seen to the right and the gateway (far right) is the entrance to Herrington Hall Lodge. A hall had existed here (off picture right) since Tudor times. When this postcard photograph was taken, the final occupant of the hall was a building contractor, Mr Harry Bell.

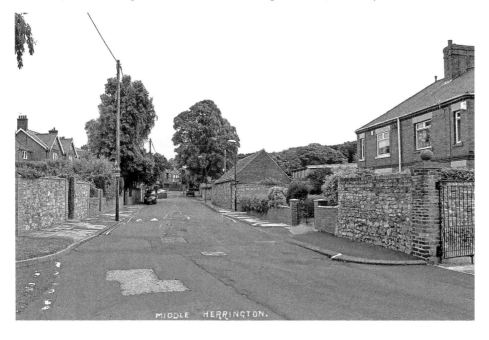

Little of this scene has changed in the intervening years. The house to the left has been either rebuilt or given dormer windows. The final Herrington Hall was demolished 1957/58 and the area is now a public park.

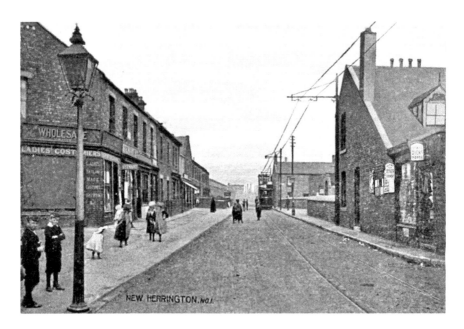

New Herrington

Another wonderfully animated view looking along a tram lined main road from New to Middle Herrington. The fashions suggest an Edwardian date for the postcard of around 1909. To the immediate left are Banks Buildings, where a ladies costumier can be seen to be trading. Beyond are Grieves Buildings, which were completed in 1881. To the far right a shop advertises itself as an 'agent for Roker Laundry'.

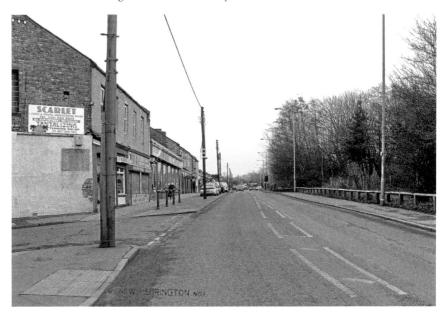

A tanning shop now operates from the old ladies costumier premises with a hairdresser next door. A motorcycle shop sits adjacent to them. The old properties between Banks and Grieves Buildings have been knocked down and a supermarket erected. Housing to the right of the scene has been demolished and New Herrington Industrial Estate now operates here.

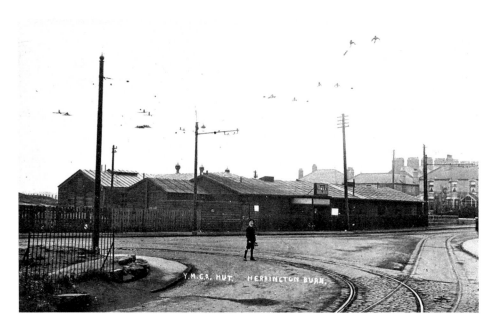

YMCA Buildings, Herrington Burn

A 1920s postcard view of the YMCA huts at Herrington Burn. Herrington Burn YMCA was founded in 1913 and took up residence in two former army huts. In the absence of traffic a young boy takes a great interest in the photographer! To the far right is Burn House.

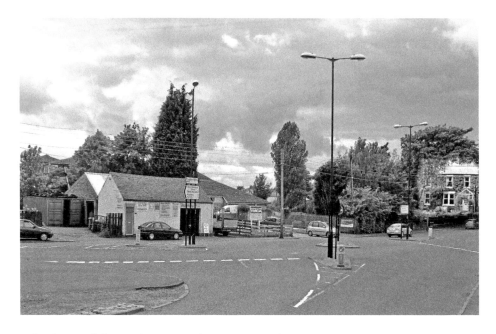

A fire destroyed the wooden ex-army huts in 1964 and a new YMCA building was opened at the end of 1967. Herrington Burn Garage (centre left) shows no obvious signs of being present on the earlier image. I have 'inset' Burn House into the present photograph, which would otherwise be obscured from this viewpoint by trees.

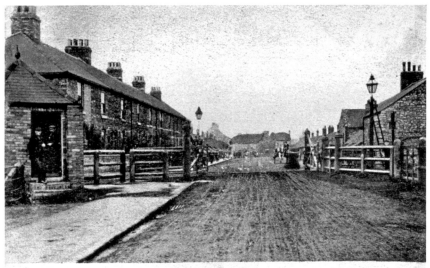

Philadelphia

Philadelphia Row

A view of the level crossing in Philadelphia around 1903. The 'manned' crossing was for the Philadelphia branch of the Lambton Railway. To the left are the houses of Shop Row and right are the miner's cottages of Chapel Row, which were originally provided by the coal owners for their workmen. The gable of the old Methodist chapel is prominent mid-row (right). In the far distance at the centre of the picture is Wellington Row.

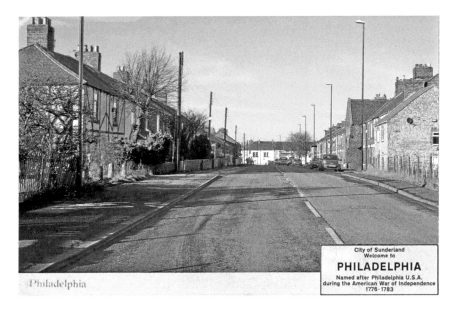

Philadelphia

City of Sunderland
Welcome to

PHILADELPHIA

Named after Philadelphia U.S.A.
during the American War of Independence
1776-1783

Alterations to properties on both sides of the road are apparent today. The red-brick chapel has been a Spiritualist Church since 1988. The old post office and general dealer's shop on the corner of Wellington Row is now a private residence. Inset: how Philadelphia got its name.

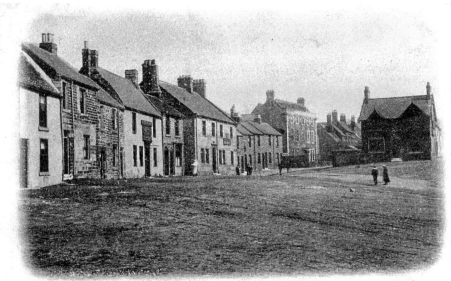

Front Street, Newbottle.

Front Street, Newbottle

An interesting picture postcard of Front Street, Newbottle that dates to around 1902. Three inns are on view, namely the Jolly Potter (centre), the Havelock Arms (left but one) and the William IV Inn to the far right. Beyond the Jolly Potter are Edith Terrace and Newbottle House.

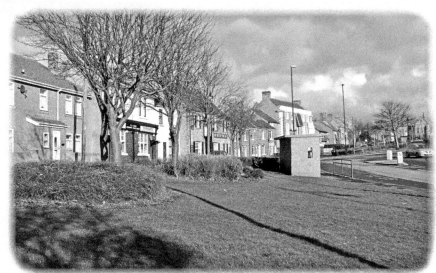

Front Street, Newbottle.

The Jolly Potter still trades today to commemorate Newbottle's pottery industry that was founded in the eighteenth century. The Havelock Arms closed in 1971 but within a couple of years re-opened as a newsagent's shop. Newbottle House is now home to a social club. Demolition of the William IV Inn means that St. Matthew's church (1886) can now be seen from this viewpoint.

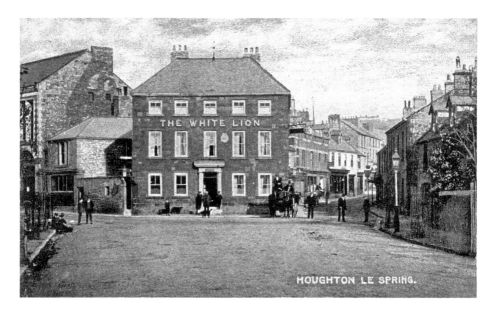

Houghton-le-Spring

A charming view looking along what was then called Durham Road to the White Lion – an old coaching inn. The picture dates to around 1903, a year before tramlines were laid. To the left is a glimpse of the old town and market hall of 1873 on Newbottle Street. On the opposite side of the White Lion is Sunderland Street, which led to Houghton Cut. The eighteenth-century Golden Lion Inn can just be seen to the far right of the picture.

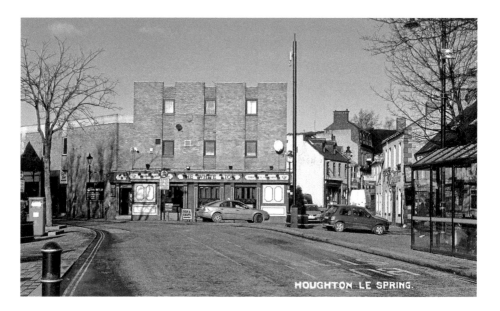

The old White Lion and market hall were demolished in the 1960s, and shops and a new inn bearing the same name built on the site. The A690 bypass was constructed around the same time and upper Sunderland Street lost many of its older buildings to the scheme, although some properties seen here at the lower end survived. The main thoroughfare in the foreground is now known as The Broadway.

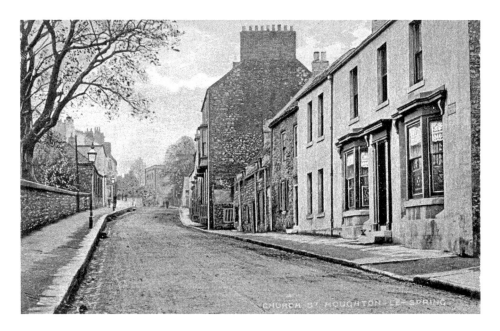

Church Street, Houghton-le-Spring

A nice colour-tinted photograph of lower Church Street that dates to around 1904. The wall of the twelfth-century St Michael and All Angels Church can be seen to the left. The houses opposite date to the Georgian period. In the distance (centre left) is the Elizabethan mansion Houghton Hall, which is thought to have been erected around 1600 by Robert Hutton, Rector of Houghton-le-Spring.

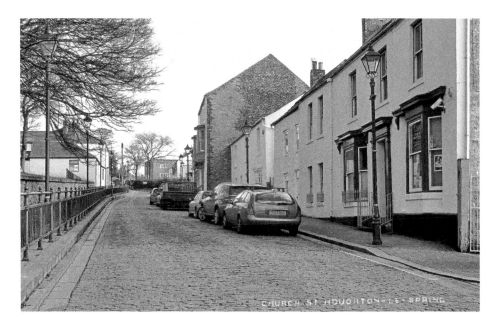

Very little has changed of this view in the intervening 105 years. A dentist's practice operates in the building to the right. Centre picture is Glendale House, former abode of the Catholic Institute and now a solicitor's office. Houghton Hall was home to a social club and then the YMCA for much of the twentieth century. It was Grade-II* listed in 1950 and is now in private hands.

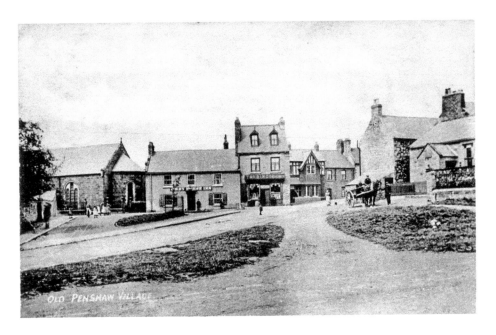

Penshaw Village

A picture postcard of Penshaw Village that dates to around 1910. All Saints church (1746) is to the left of the picture. Next to the church is the Grey Horse Inn and to its right is 'cash grocers' T. & R. Bird. Beyond the grocery shop is the Ship Inn and Eden House. The gable of the end property of Gordon Terrace can be seen to the right.

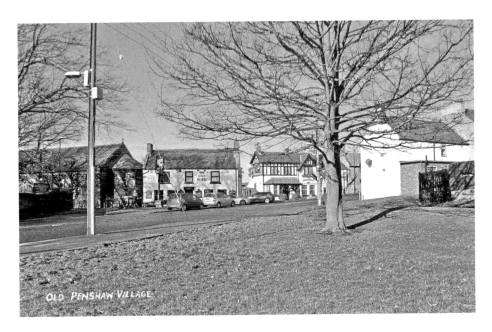

The grocery shop no longer stands in the village, which allows a better view from this standpoint of the old Ship Inn – now called The Monument. There is just a glimpse of the garden wall of Village Farm to the far right of the picture. The village still retains much of its old rural charm today.

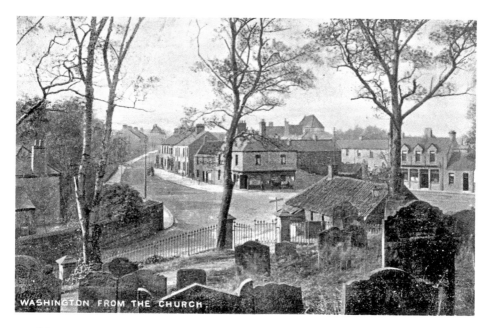

Washington Village

A lovely view of Washington Village taken from the graveyard of Holy Trinity church in around 1908. At the centre of the photograph is Lambert's shop. In the foreground to the right are the village blacksmith's premises and far right, at the edge of the village green, is the Cross Keys Inn. On the skyline (centre right) is Our Blessed Lady Immaculate church, which was built between 1877-78 by A.M. Dunn.

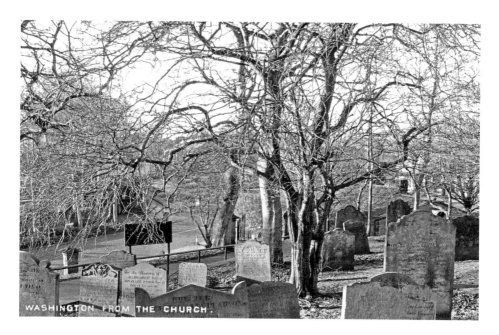

In 2009 the clusters of headstones remain as they were, but tree growth now restricts our view of the village from this viewpoint. The roof of the smithy – now a restaurant and some detail of the Cross Keys beyond are just visible.

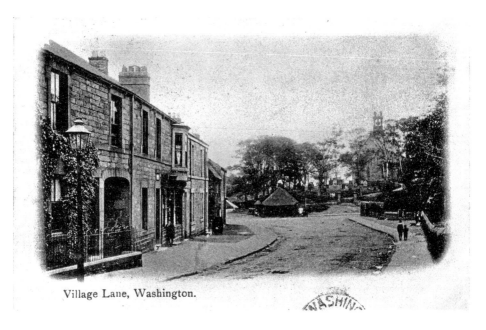

Village Lane, Washington.

Village Lane, Washington

A photograph taken around 1902 in the opposite direction to the previous picture. The old medieval church of Washington was demolished in 1830 and its replacement (right) erected over the next three years by J. & B. Green at a cost of £1,096. Additional building work was carried out in 1882/3 and 1902. The site is much older, however, and may have once have housed a Saxon church. At the centre of the picture is another view of the blacksmith's shop. The terrace to the left is Dickinson Place, which was built in 1877.

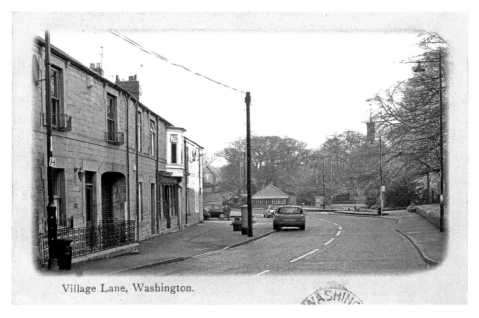

Village Lane, Washington.

The rebuilt church bell tower of 1962 can be seen in this 2009 view. The red painted premises of the recently closed (and much missed) post office can be seen centre left. Lambert's shop and an adjacent structure at the end of the terrace were demolished in the 1960s.

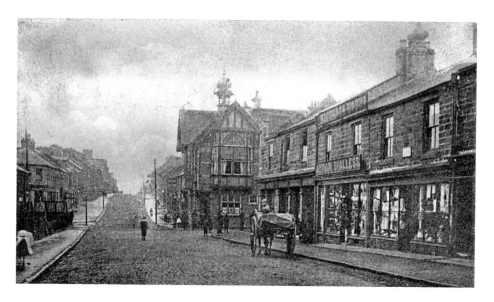

Front Street, New Washington

In this view of New Washington that dates to around 1903, the old direct line of Front Street can be observed. Centre picture, at the street's junction with Spout Lane, is the New Inn. On the opposite corner (centre right) is the Washington branch of the Birtley Co-op, which opened in 1874 and was so successful that a major extension was required by 1892. Alongside the Co-op are the premises of Arthur Shalless in Victoria House. On the opposite side of the road (left) is the grocery and drapery shop of R. Elliott.

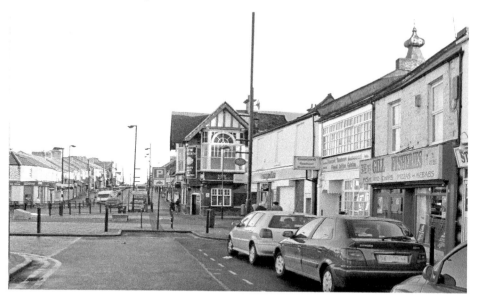

The cupola on the roof of the inn, now called the New Tavern has gone, but the building itself looks much the same. The Co-op still operates a food outlet in part of its old premises, but the rest of the building is now divided up into independent retail outlets. Far right on Victoria Place in 2009 are two Indian restaurants and a fish and chip shop. The grocery and drapery shop to the left is now a betting shop, but operated as a bank for many years. This part of Washington is now known as Concord.

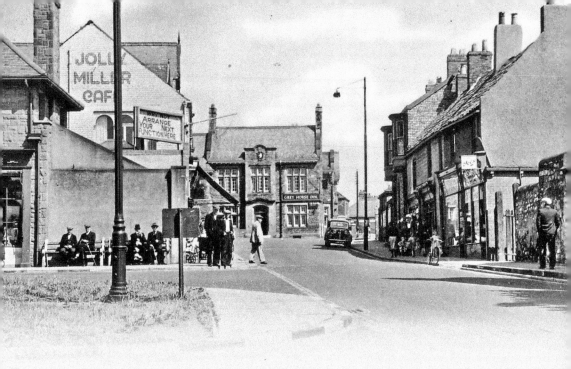

chapter 6

Our Village Neighbour

Whitburn

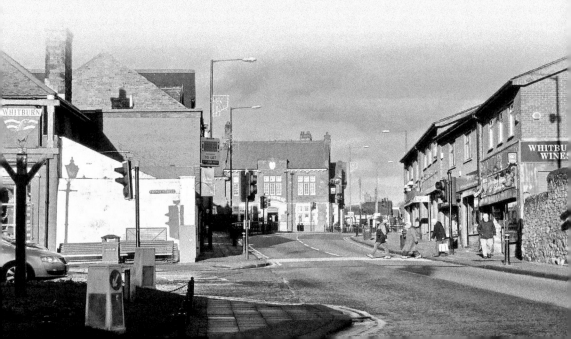

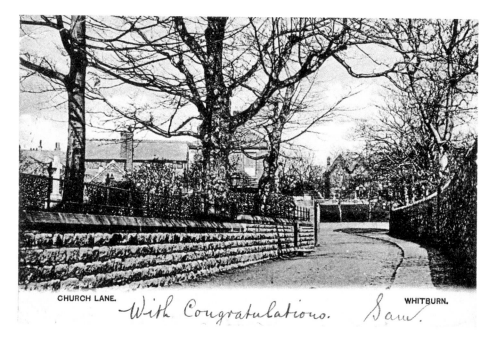

CHURCH LANE. *With Congratulations.* Sam. WHITBURN.

Church Lane Whitburn

A postcard of Church Lane in Whitburn around 1902 with the churchyard to the left. Beyond the lane on Front Street is a glimpse of Manor House (1869), which was built by brickworks owner Thomas Barnes. The house at the end of the lane on the left is called 'The Borders'. It was named after the regiment that a former owner once served in.

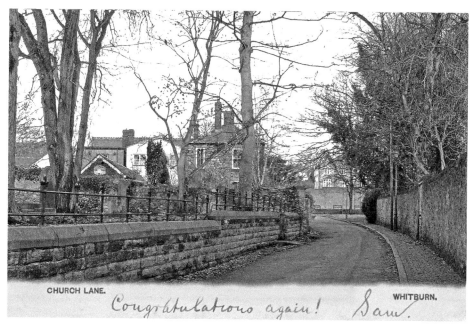

CHURCH LANE. *Congratulations again!* Sam. WHITBURN.

Given that 105 years separate these two images, remarkably little has changed on this modern view except for some rear extension work to the properties adjacent to The Borders. Manor House was renamed Whitburn House in 1928.

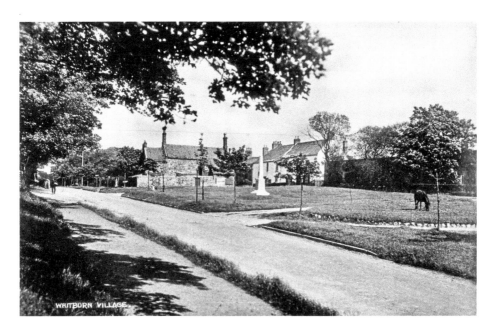

Whitburn Village

A grazing horse gives this view of Whitburn Village in around 1922 a quaint rural look to it. The war memorial (1920) sits at the centre of the picture and is dedicated to those Whitburn and Marsden servicemen who lost their lives in two World Wars. Cross House, to the left of the memorial and built in 1810, is so called because it was erected 'across' the village green.

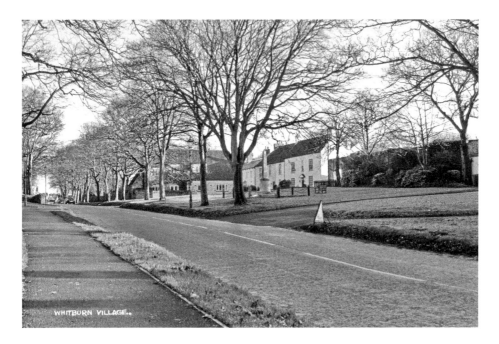

Over eighty years later, the young trees in front of the war memorial have matured nicely. Whitehouse Farm seen to the right of the memorial is now a private residence and High Gardens can be observed further right again. Cross House was renovated in the 1960s.

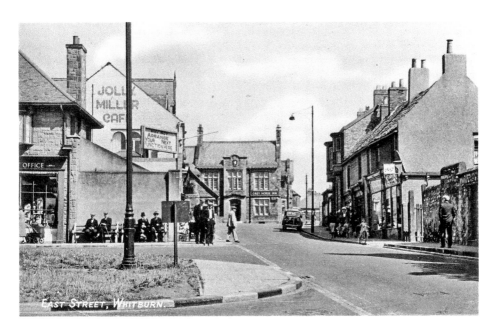

East Street, Whitburn

A picture of East Street, Whitburn in the mid 1930s. At the centre of the picture is the Grey Horse Inn. An old map confirms that an inn of that name was here in 1855, but the premises featured in this view are of a later date. The village post office and the Jolly Miller Café can be seen to the left.

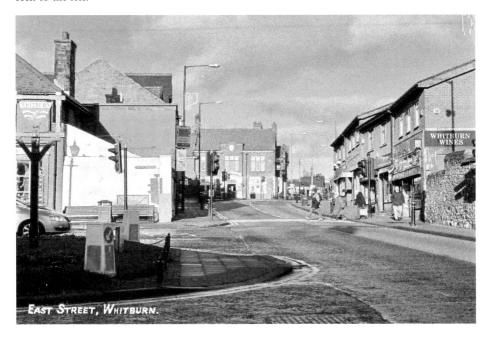

Today, the Grey Horse looks much the same as it did seventy-three years ago. To the left, the post office is now a costume hire shop and the café building is currently up for sale, having recently been a furnishing and coffee shop. The public seats remain exactly where they were over seven decades ago. On the right of the picture, in rebuilt premises, are a wine shop and Wilson's of Whitburn.

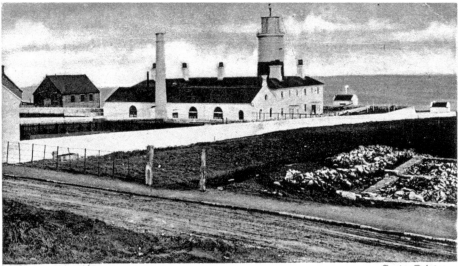

Lighthouse and Coastguard Station. Souter Point.

Souter Lighthouse, Lizard Point

Souter Lighthouse around 1903. It was originally planned for a site around 1 mile down the coast at Souter Point. It's designer John Douglas, however, realised that higher cliffs at Lizard Point would mean a shorter and therefore cheaper lighthouse. It was completed in 1871 at its more northerly location, but kept its original name to avoid confusion with a Lizard Point lighthouse that already existed in Cornwall. It was the first lighthouse to use alternating current as a power source. Left of the lighthouse buildings is an old Primitive Methodist chapel.

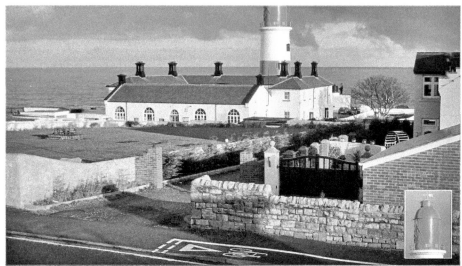

Lighthouse and Coastguard Station. Souter Point.

Sometime after 1903, the lighthouse lantern room was extended (see inset). It was taken out of service in 1988 by Trinity House and is now a National Trust property. Today, the lighthouse looks quite resplendent after recent refurbishment work. The nearby colliery village of Marsden often referred to as the 'village that vanished' was demolished in the 1950s.

chapter 7

Mementoes of Old Sunderland

A Sunderland lustre frog mug once bought by a sailor visiting the port. A borough coronation medal presented to a child at James William Street School. A picture postcard featuring our much lamented town hall. An old ferry token that has lain at the back of a drawer for many years.

Items such as these are now much sought after by collectors and have become the 'Mementoes of Old Sunderland'.

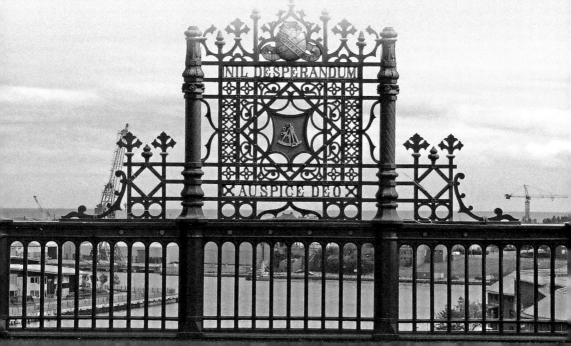

An Early Sunderland Postcard

Many 'past' scenes in this book originate from old postcards. The earliest illustrated postcards first appeared around 1894, but they did not carry actual photographs – they were engraved from line drawings. This small, early Sunderland card is thought to date from between 1894 and 1901.

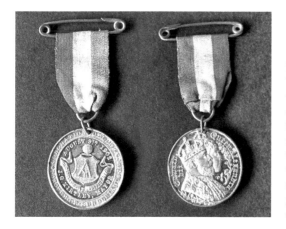

Sunderland Coronation Medal 1902

The Borough Road scene of 1910 shows two flags flying at half mast — possibly due to the death of King Edward VII. This Sunderland Borough medal was issued for his Coronation in 1902. The original Coronation day was planned for 6 June, but was changed to 9 August when the King developed appendicitis. Commemorative pieces bearing the later date (as this medal does) are much rarer.

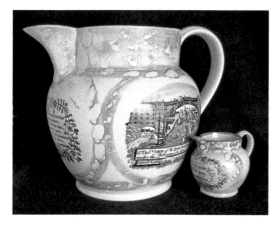

Little and Large

An example of the range of 'hand thrown' lustre jugs that were made in the Sunderland potteries in the nineteenth century. Our bridges and nautical or religious rhymes were popular decorating themes.

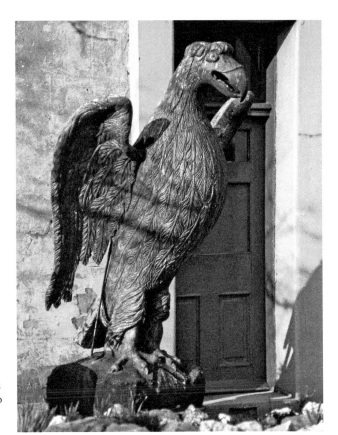

The Eagle has Landed
The original eagle that sat on the Eagle Tavern in High Street East. In the 1970s it lived in a garden in Deptford Terrace and is thought to have 'emigrated' to Australia with its owners. Note its 'raised' wings.

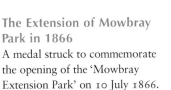

The Extension of Mowbray Park in 1866
A medal struck to commemorate the opening of the 'Mowbray Extension Park' on 10 July 1866.

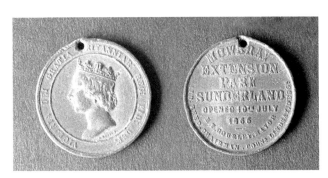

Opening of Sunderland Museum and New Winter Gardens in 2001
A medal struck to commemorate the official opening of the Museum and new Winter Gardens on 19 July 2001.

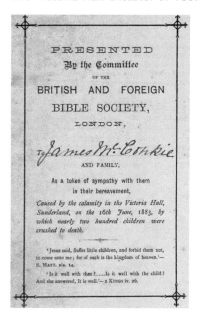

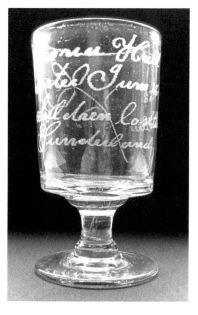

Presentation Bible
Dedication page of a bible presented
to the author's maternal great
grandfather and family on the sad loss
of daughter Nellie in the Victoria Hall
Disaster.

Disaster Glass
An engraved glass commemorating the
Victoria Hall Disaster. The inscription
reads: 'Victoria Hall Disaster June
16th 1883 – 200 children lost there
(sic) lives Sunderland'. Eventual
confirmation showed that 183 lives
were lost on that fateful day.

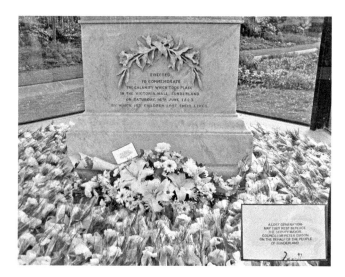

**Return of Victoria Hall
Disaster Monument to
Mowbray Park
12 April 2002**
In the 2002 ceremony, 183
children laid flowers around
the monument – one for
every child that had perished
in the disaster. Inset: the
Deputy Mayor's tribute
on behalf of the people of
Sunderland, which reads 'A
lost generation. May they
rest in peace.'

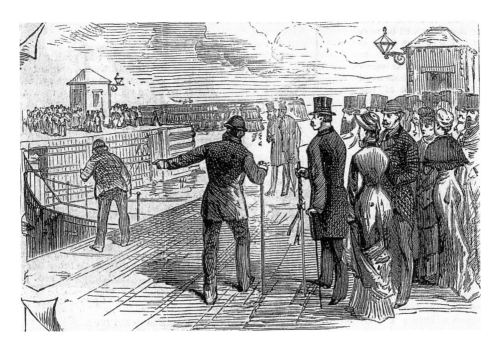

The Opening of the Sea Outlet in the South Dock

The Earl of Durham opens the new dock as depicted in *The Illustrated London News* on 30 October 1880.

QUEEN ALEXANDRA BRIDGE

Commemorative Medal

A medal struck to commemorate the opening of the Queen Alexandra Bridge on 10 June 1909 by The Right Honourable: The Earl of Durham K.G. The Earl was presented with one of these medals at the ceremony.

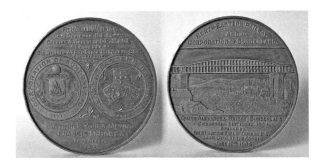

Bridge Token

A rare halfpenny bridge token. Queen Alexandra Bridge tolls were not abolished until 28 March 1928.

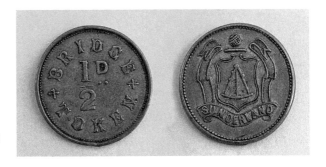

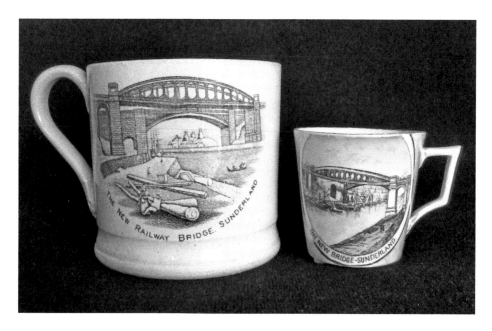

The Rail Bridge — England V Germany

Both of these pieces were manufactured around 1879 to commemorate the opening of Sunderland's new rail bridge. The pottery mug (left) is English, and was possibly made at Balls Pottery, Sunderland. The porcelain cup (right) was manufactured in Germany. By 1879, Sunderland's pottery industry was in decline due to increasing competition from Staffordshire and abroad.

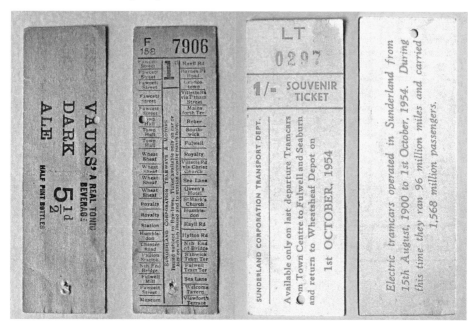

The Tramways

By 1924, the 'Shop at Binns' advert was a common sight on Sunderland's trams. Another of our other famous institutions 'Vaux Breweries' advertised on tram tickets (see left) The very last Sunderland tramcar ran on 1 October 1954. A souvenir ticket for that journey is shown right.

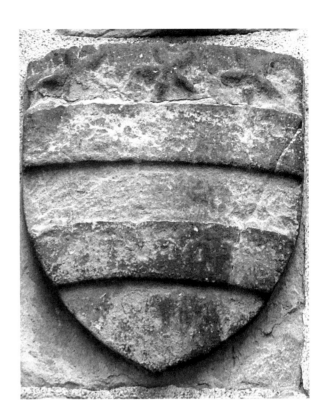

The Stars and Stripes

The Washington family Crest above the main doorway of Hylton Castle, showing three stars and two stripes. This is the earliest known representation of the stars and stripes of the American flag.

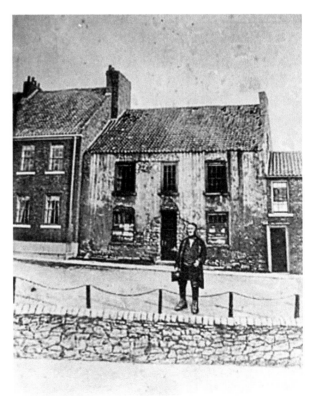

Old Sunderland Character Dickie Chilton

A Victorian lanternslide (1860s) of Dickie Chilton taken outside of his house at Bishopwearmouth. It was known as 'Bleak House' because of its derelict condition. He died in The Sunderland Workhouse 28 November 1875 aged 83.

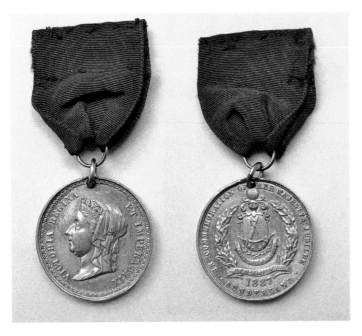

Queen Victoria Jubilee Medal

A Sunderland Borough medal of 1887 commemorating the Golden Jubilee of Queen Victoria. The medal recipient is thought to have been a member of Sunderland's Special Constabulary.

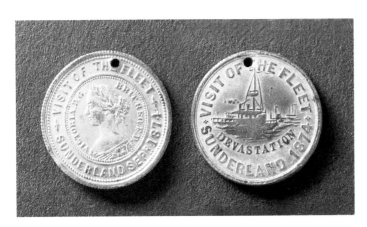

Visit of the Fleet

A medal struck to commemorate the visit of the Fleet to Sunderland in September 1874. Its reverse shows H.M.S. *Devastation*, an iron second class battleship that was built at Portsmouth in 1871.

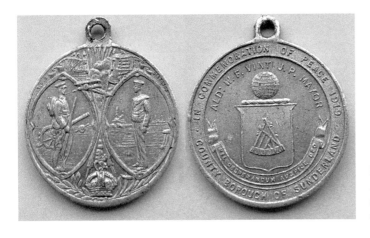

Peace Medal

A Borough of Sunderland medal struck in 1919 in commemoration of peace.

Nil Desperandum Auspice Deo

Sunderland has used 'Nil Desperandum Auspice Deo' as its official motto since 1849 and it has subsequently featured on many commemorative items. It does, however, have earlier connections to the great iron bridge of 1796. The above locally made creamware mug, which dates to the late eighteenth / early nineteenth-century displays an early representation of that motto. Below the iron bridge, which is flanked by the figures of 'Genius' and 'Minerva', are the words: Nil Desprandum (sic) Auspice Deo. (lower left and right of the transfer print).

In the first printed history of the town (1819), author George Garbutt describes the 1796 bridge deck as: 'a neat iron balustrade, above which in the centre of each side, is the following inscription, chosen as a pious record of the successful completion of the work: NIL DESPERANDUM AUSPICE DEO'. His contemporary translation reads 'nothing to be despaired of under the auspices of providence'.

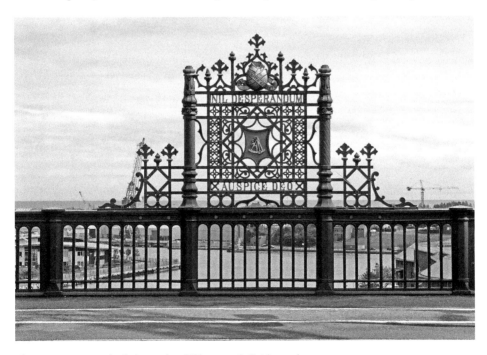

The city motto on the balustrade of Wearmouth Bridge today.

Bibliography

A Historical and Descriptive View of the Parishes of Monkwearmouth, Bishopwearmouth and the Port and Borough of Sunderland by George Garbutt 1819.

The Queen's Album of Sunderland published by William M. Carr.

Sunderland – River Town and People by Geoffrey Milburn and Stuart Miller. 1988.

Sunderland – The Biggest Shipbuilding Town in the World by Alan Brett and Andrew Clark 2005.

Sunderland – A Century of Shopping by Phillip Curtis. Published by The People's History 1999.

The Venerable Bede: His Life and Work by Canon Rawnsley with an Account of The Bede Memorial by Charles C. Hodges. Published 1904 by Hills & Co.

A Handbook to the Church of St. Peter Monkwearmouth by James Patterson. Published 1912 by Hills & Co.

History of Sunderland by Tom Corfe. Published by Frank Graham 1973.

Where Ships are Born – Sunderland 1346 to 1946 by J.W. Smith and T.S. Holden. Published 1946 by Thomas Reed & Co.

Seaburn and Roker by Pat O'Brien and Peter Gibson. Published 1997 by Tempus Publishing Ltd.

Around Washington by Stuart Miller and George Nairn. Published 1998 by The People's History.

Ryhope in old picture postcards by J.N. Pace. Published 1985 by Zaltbommel/ Netherlands.

Houghton in old picture postcards by Ken Richardson. Published 1985 by Zaltbommel/ Netherlands.

Around Hylton Castle by Alan Brett. Published 1997 by The People's History.

Railways of Sunderland. Tyne and Wear County Council Museums. Published 1985.